At First Light

Poems & Photography by Wende Essrow

BUFFALO
HERITAGE
PRESS

Buffalo Heritage Press
266 Elmwood Avenue, #407
Buffalo, NY 14222
www.BuffaloHeritage.com

BUFFALO
HERITAGE
PRESS

Book design by Daniel Essrow

ISBN: 978-1-942483-41-0 (softcover)
ISBN: 978-1-942483-42-7 (hardcover)

Library of Congress control number available upon request.

Printed in the U.S.A.

10 9 8 7 6 5 4 3 2 1

DEDICATION

To my husband and best friend, Michael, who has encouraged my artistic pursuits for so many years. Thank you for all the times you have pulled the car over to let me capture the sun shining on a horse's shoulders, or the moon illuminating a field of snow.

ACKNOWLEDGMENTS

"You are a cloud. Sail."

Scrawled in ballpoint pen in the margin of a poem written on lined notebook paper, these were the first words written to me by a dear teacher who understood my need to write. He and I wrote a series of poem-letters that spanned four decades. He has since passed on.

I've been sailing ever since, George. I hope you can hear me.

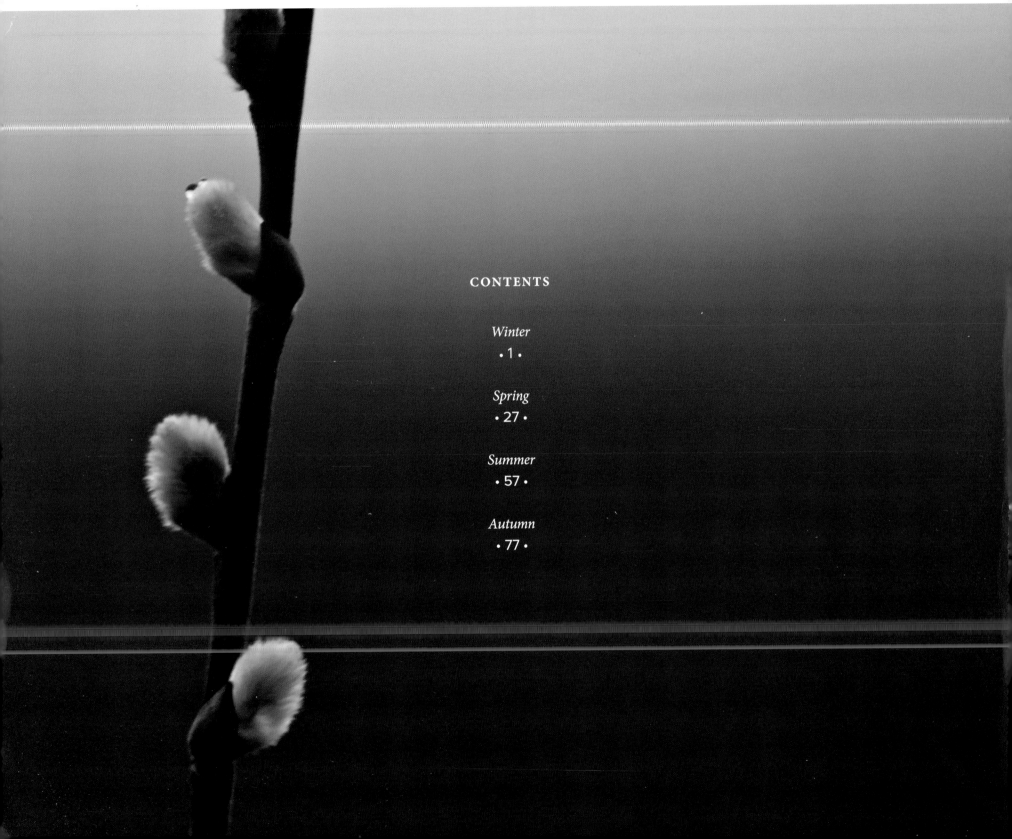

CONTENTS

INTRODUCTION

My words, painting, and photography are a humble desire to honor the master designer who keeps giving birth to delicate snowflakes and shining light through butterfly wings. It is the extraordinary beauty of the natural world that motivates me.

The woods are my home. The studio is where I keep my paintbrushes and ink.

Creating *At First Light* is how I have started my days and ended them. I hope that you find it the perfect way to get in a peaceful mood to start your day as you sip your first cup of coffee, or that paging through the natural beauty it reveals provides you with a serene way to end your day.

I hear dawn calling. Come with me and watch the sun slowly rise through the treetops.

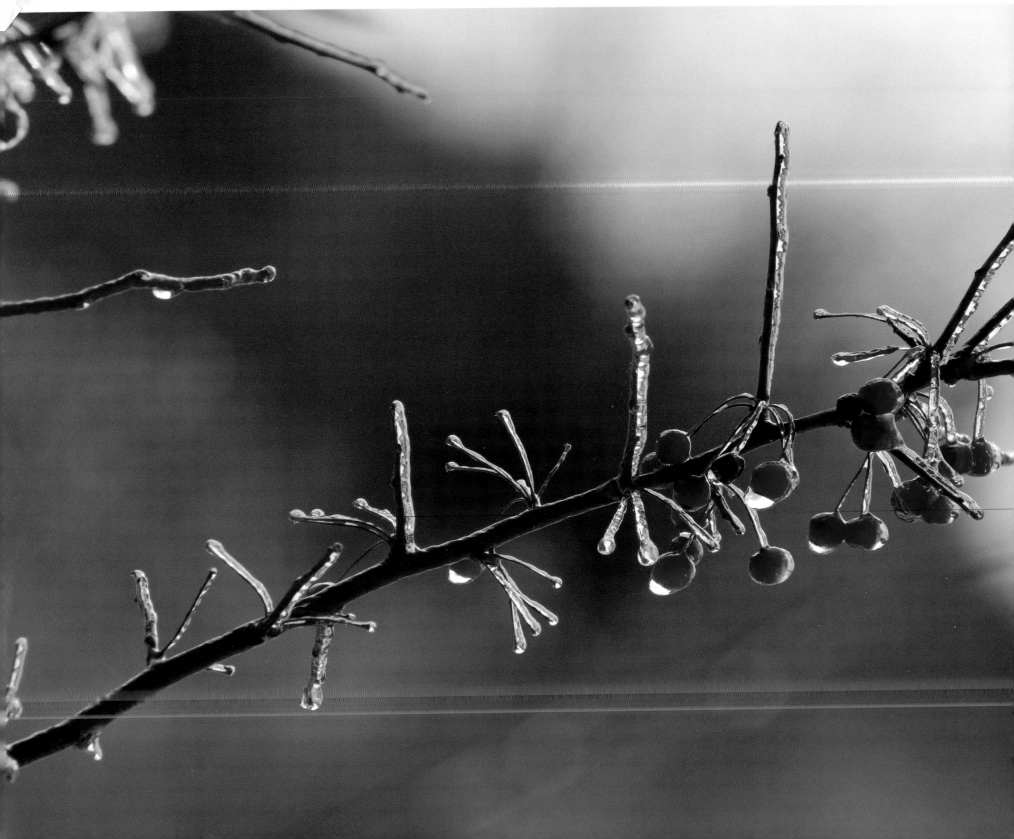

CRYSTAL SIGNATURE

Skiing at sunrise,
no sound but the sound of white.
Gliding through snow world,
pausing in a perfect cave.
Breathing slowly inside winter's womb.
Tender arch of laced branches beckons.
Embraced by the crystal signature of nature's voice…
Soft, silent, untouched snow,
the morning gift
early wanderers know.

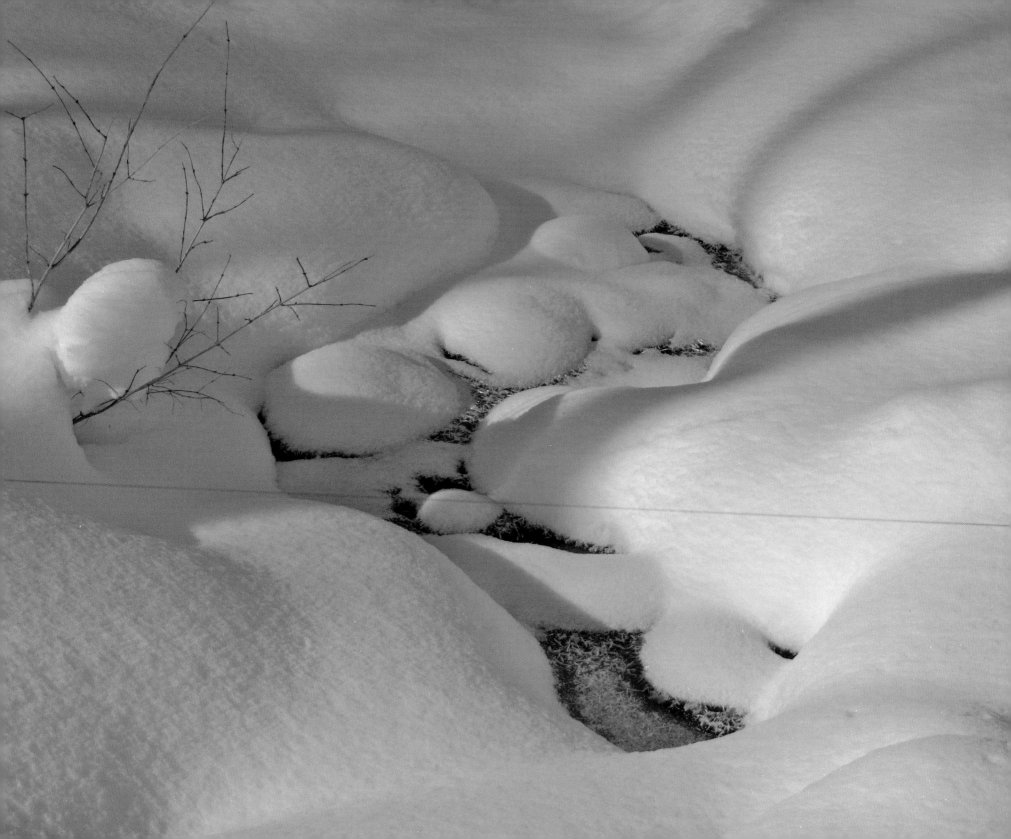

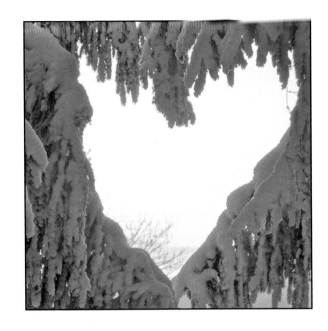

PINE HEART WINDOW

Like a crowd of celebrants, arms raised high
to greet the sun as it ascends the sky,
the snow covered branches call me in,
time for forest prayers to begin.
Through a pine heart window I see snow dust
suspended in golden light
as winter bares her soul
to my delight.

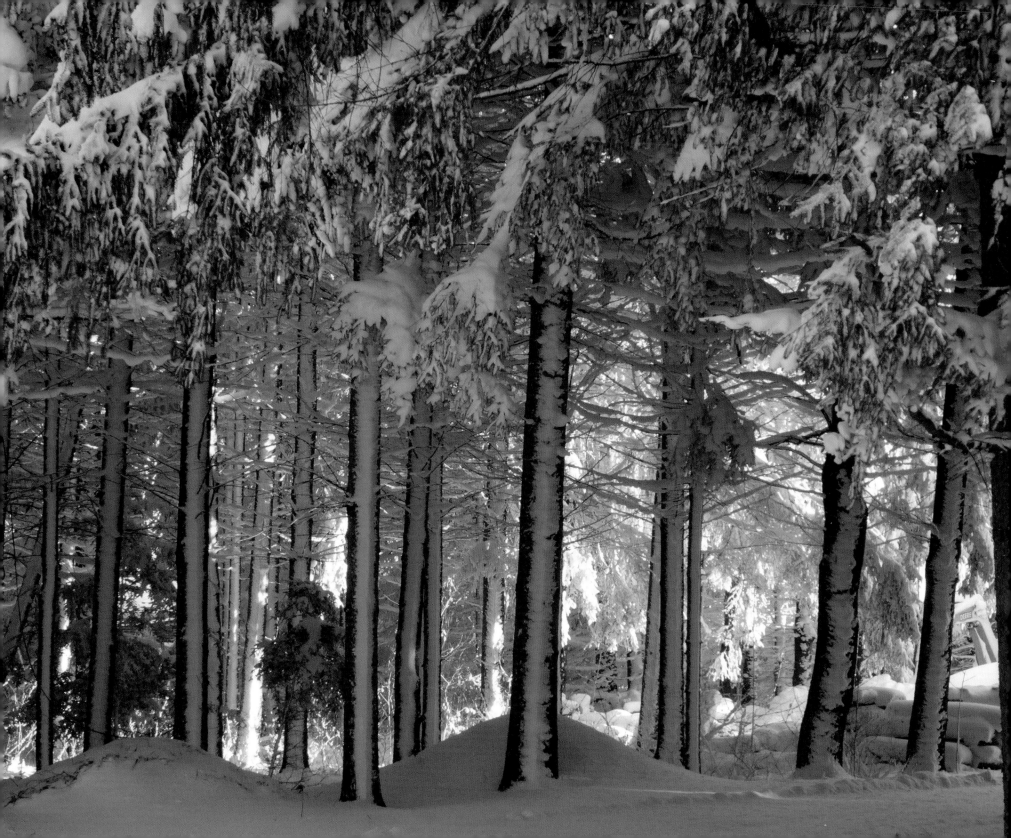

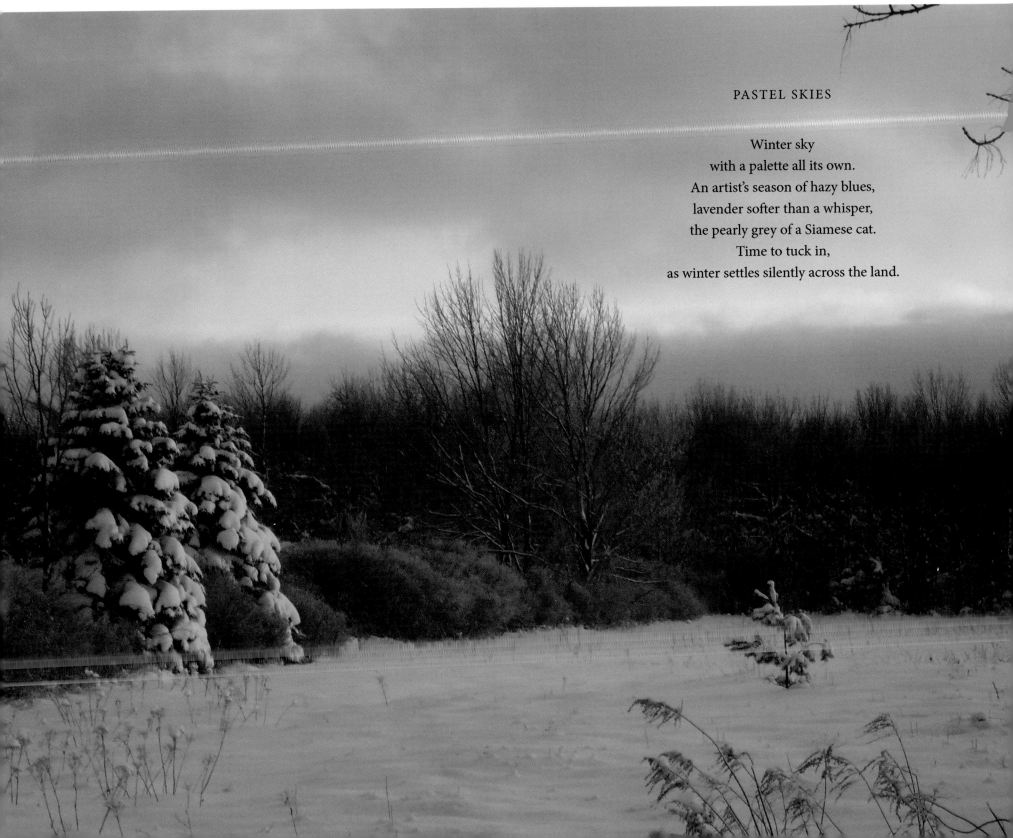

PASTEL SKIES

Winter sky
with a palette all its own.
An artist's season of hazy blues,
lavender softer than a whisper,
the pearly grey of a Siamese cat.
Time to tuck in,
as winter settles silently across the land.

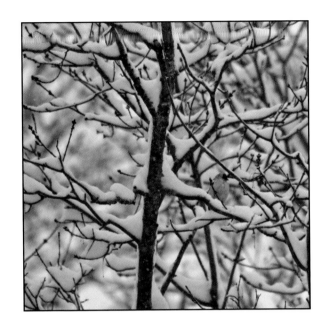

LITTLE LEMON DROP

A snowglobe day of pure white.
The woods all covered in snow,
I hug my mug of coffee, no place special to go.
The clouds above shrouded in dreary grey,
over the blank canvas of yet another December day.
And then a perfectly yellow goldfinch stops by,
like a dream thought from the sky
Little lemon drop bird against all this white,
bringing my winter weary eyes pure delight.

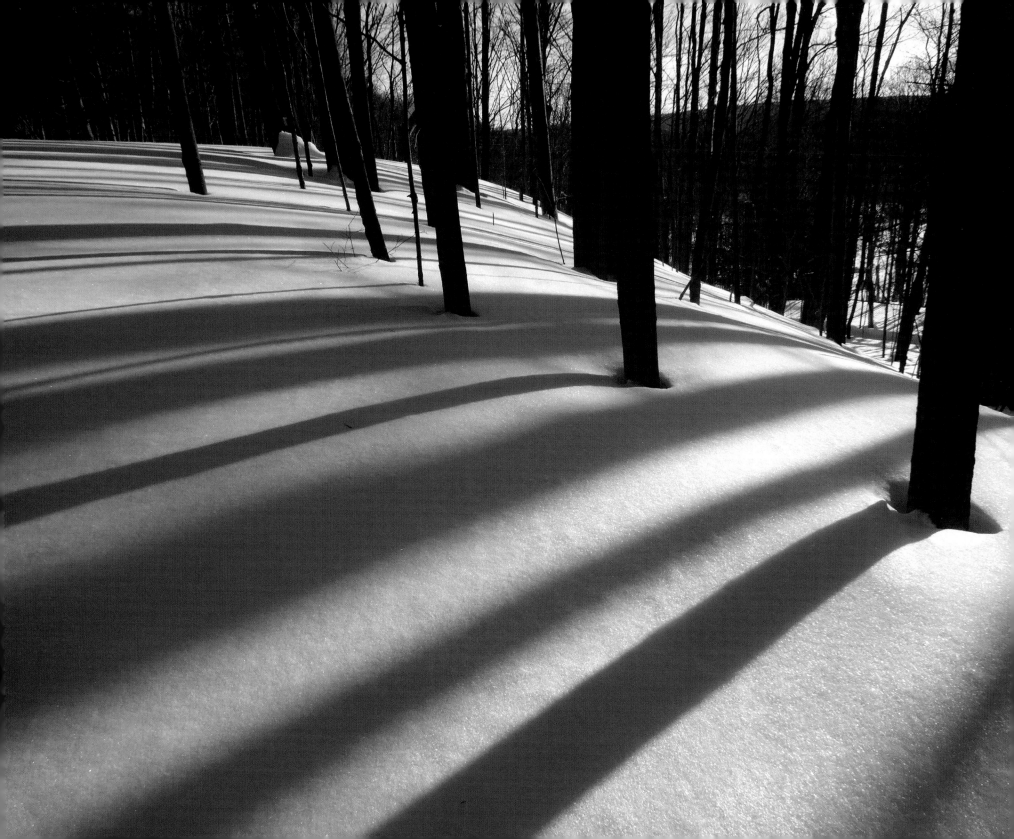

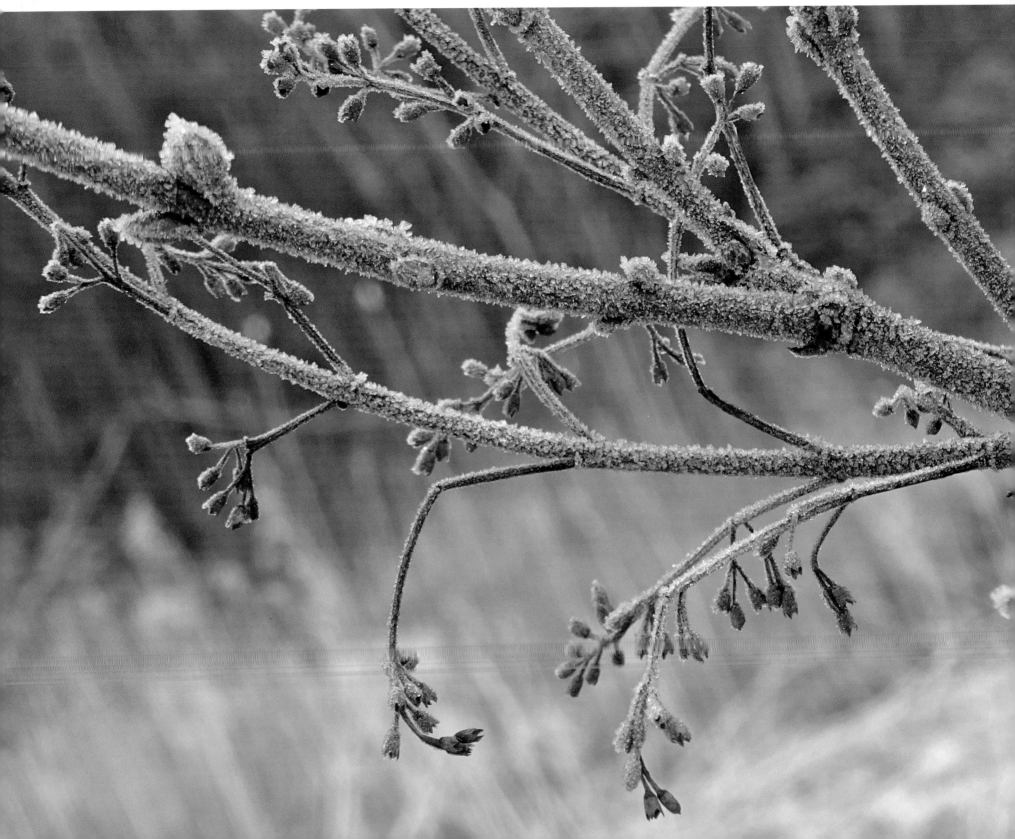

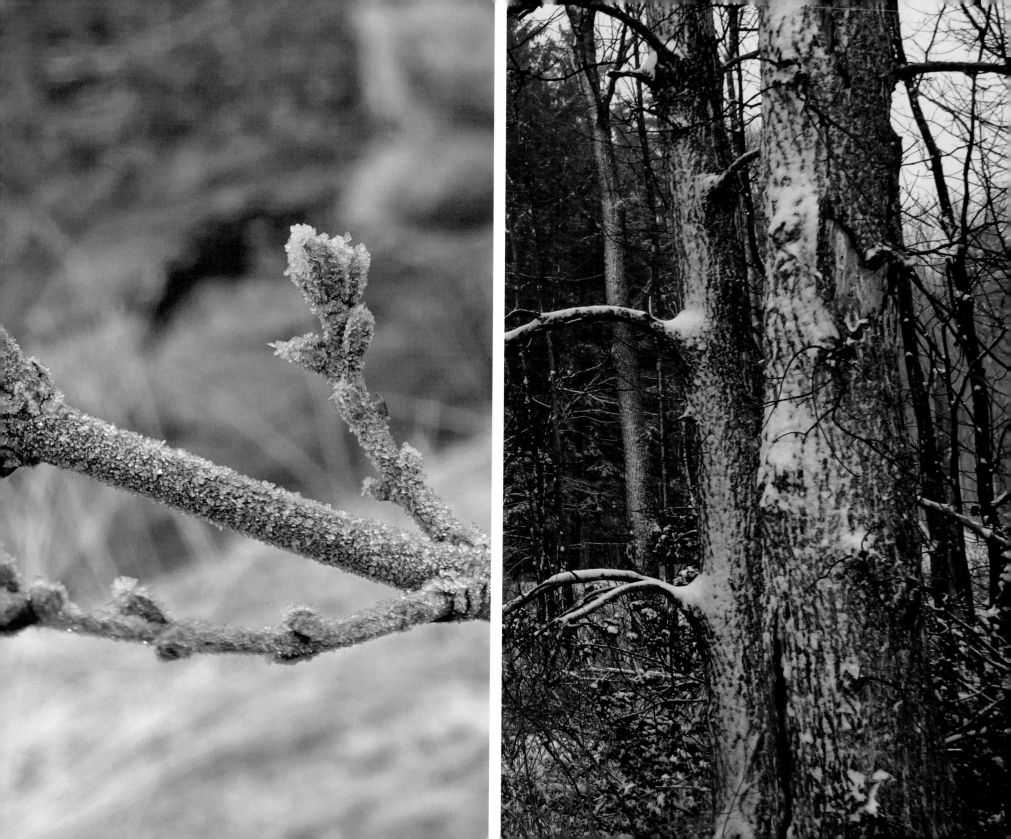

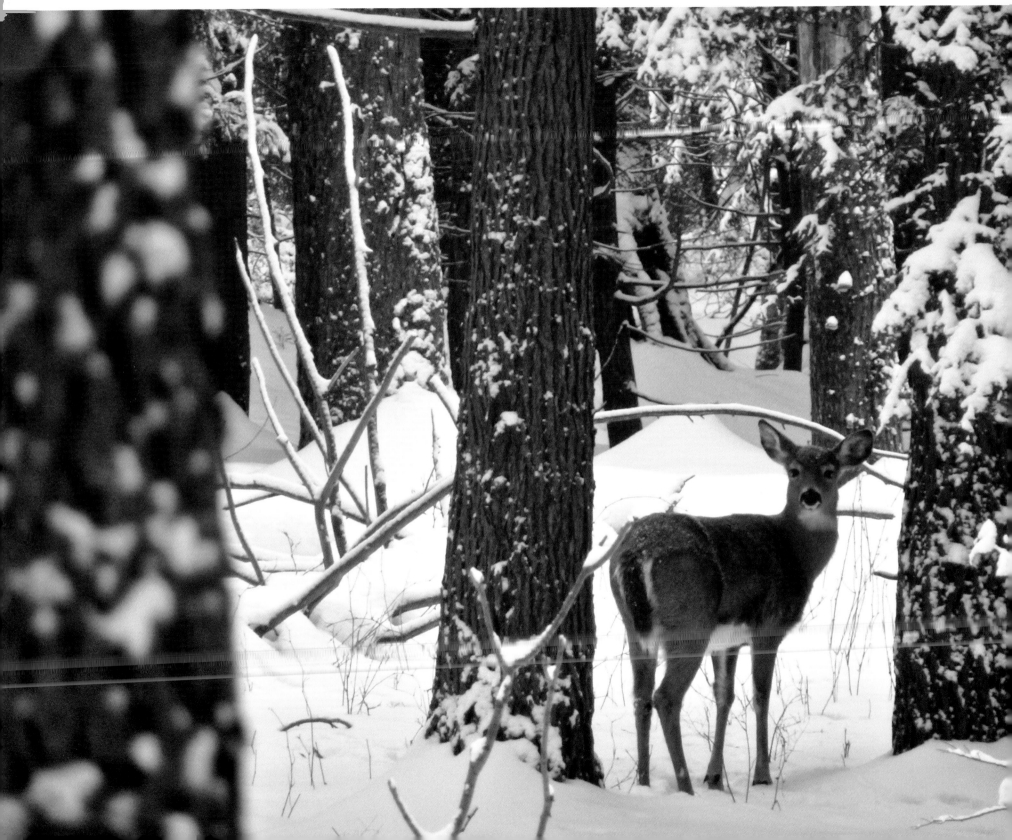

SNOWFLAKES ON YOUR NOSE

I pause and turn
a quarter round,
sliding a ski length back,
breath held…
I send a thought your way.
You are safe with me,
just another forest dweller on this quiet winter morn.
You shyly lift your head,
I see snowflakes on your nose.
We speak a silent forest word as far as I can tell.
Slowly skiing on, I nod a small farewell.

NO NEED TO RUSH

I lean my poles against the fence where two horses share
this winter morning's frosted air.
Sunrise hush, no need to rush…
I follow my skis while breaking trail,
they lead me through the hills and on I sail…
Owls at rest now, roosters awake,
Sunbeams piercing each frozen flake.
Winter morning, cheeks aglow,
I follow my skis wherever they go.
Sunrise hush, no need to rush,
as the horses seem to know.

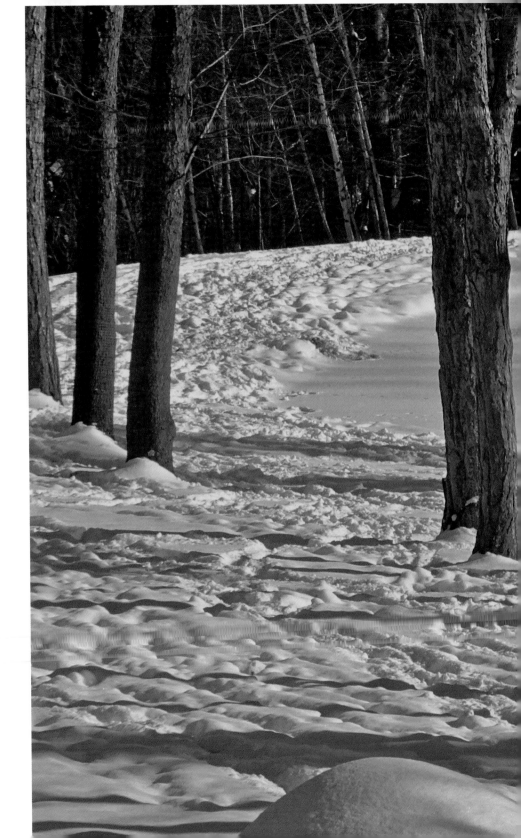

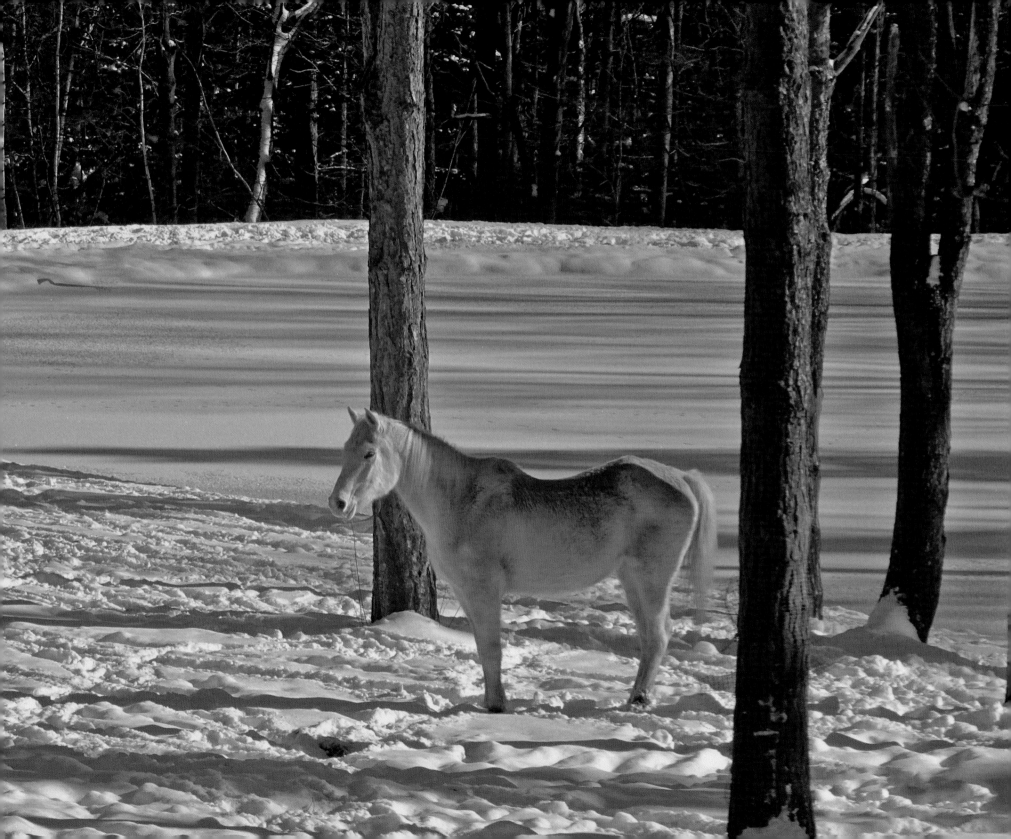

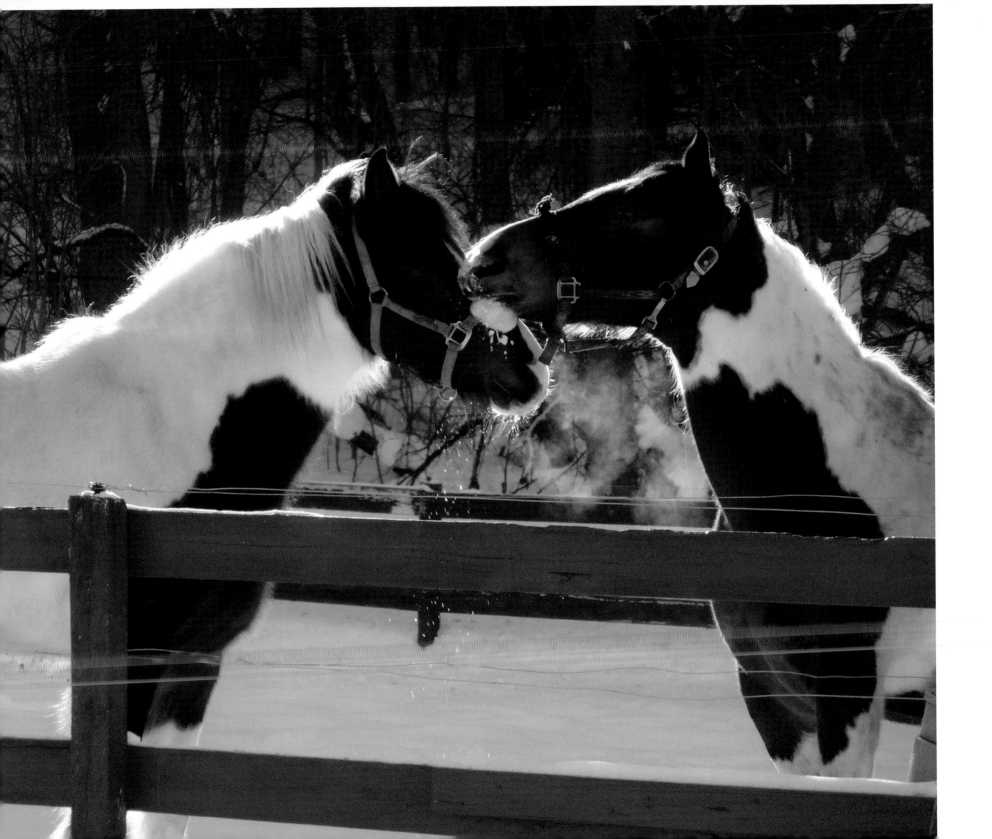

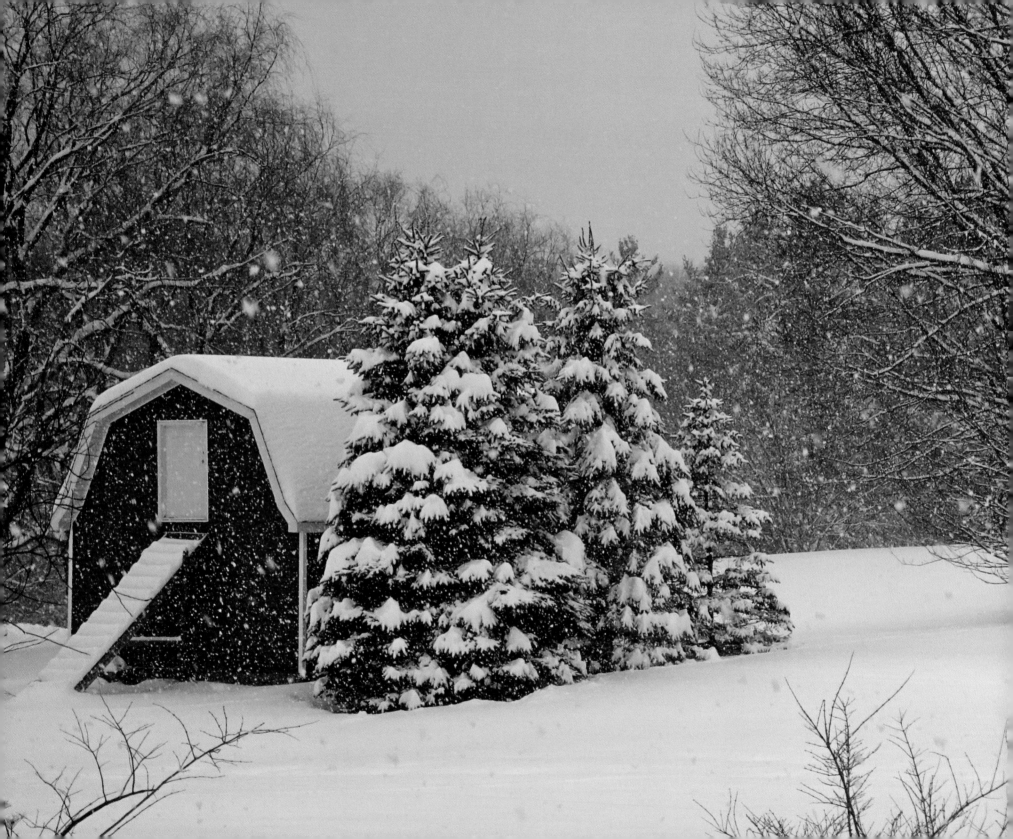

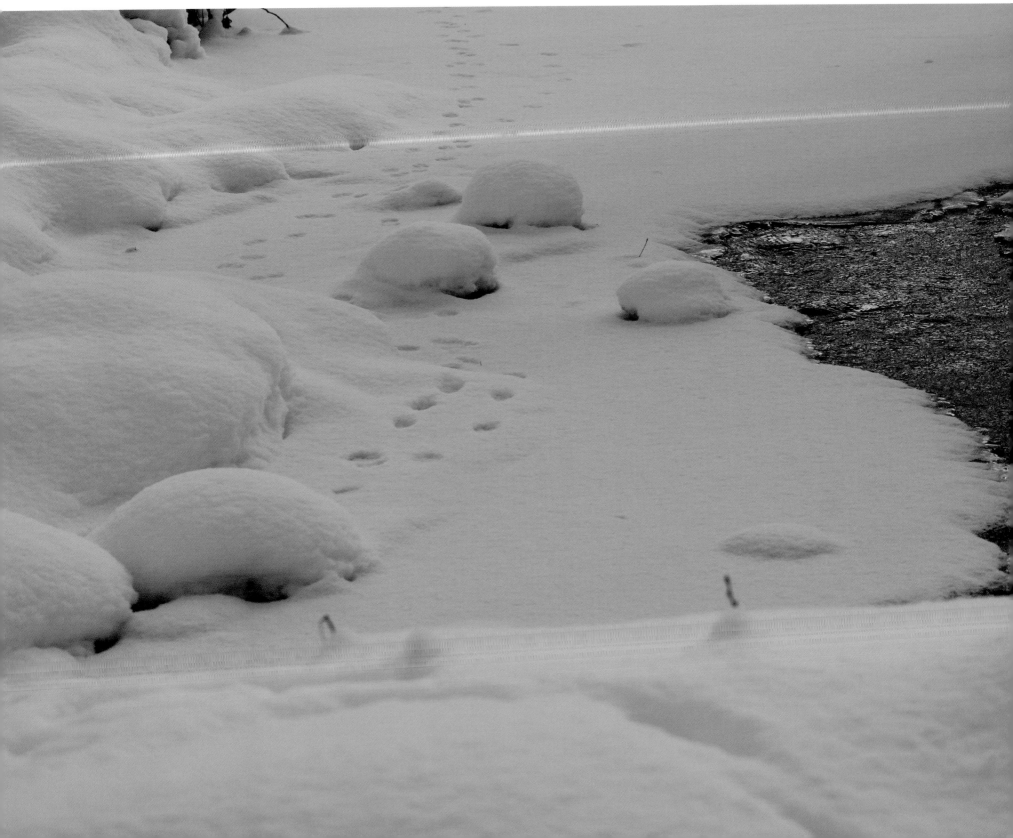

TRACKS

In the shadow of the full wolf moon,
a coyote stalks
silently across
the ice blue pond.
The scent of a stag fills the frigid night air.
Canine gaze intent,
ears turned outward towards the woods
where the hunted one lies
motionless beneath the snow laden boughs,
waiting for coyote to pass on by.

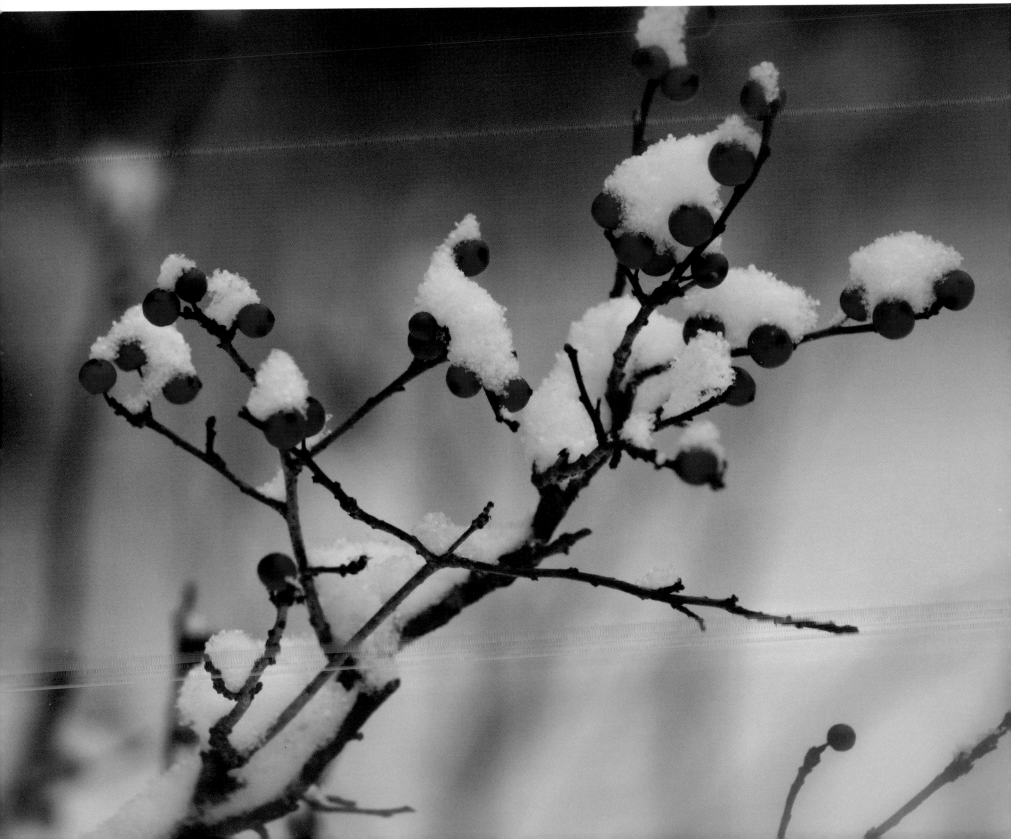

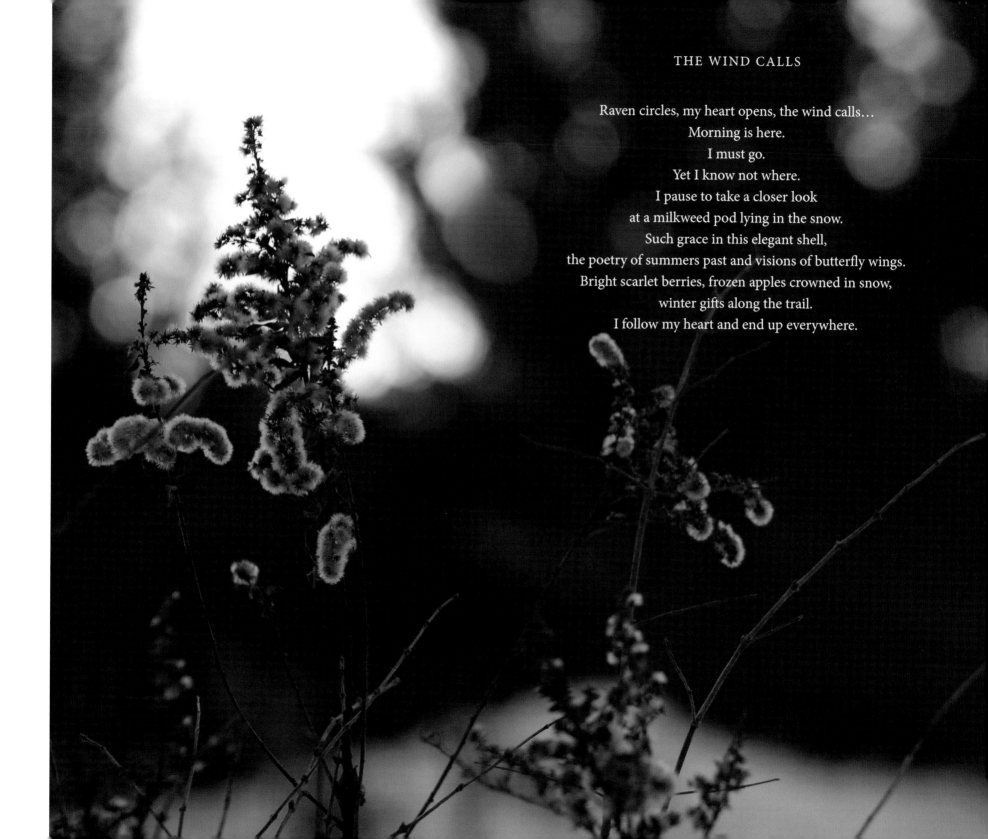

THE WIND CALLS

Raven circles, my heart opens, the wind calls…
Morning is here.
I must go.
Yet I know not where.
I pause to take a closer look
at a milkweed pod lying in the snow.
Such grace in this elegant shell,
the poetry of summers past and visions of butterfly wings.
Bright scarlet berries, frozen apples crowned in snow,
winter gifts along the trail.
I follow my heart and end up everywhere.

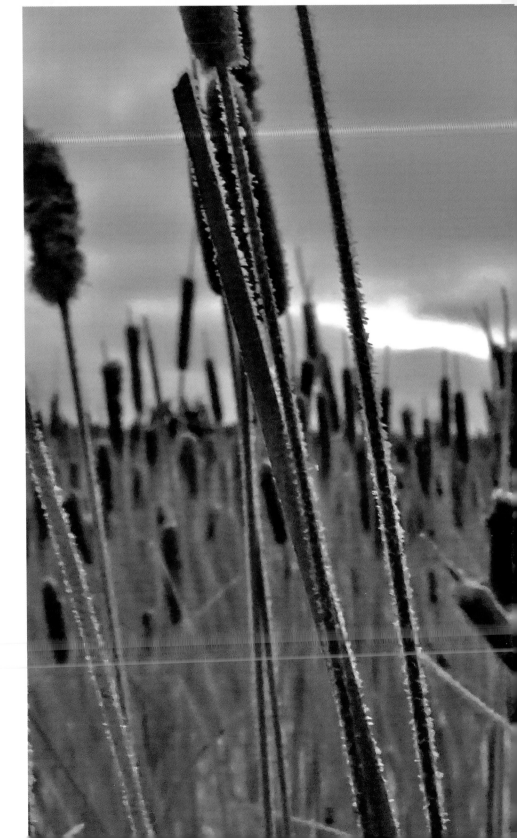

FROZEN FIELDS

I often stop and stare across frozen fields of wild grass
as I wander here and there.
Rows of frost-coated cattails
in the morning sun,
hoar frost glistening on every tree.
Pink dawn light on all I see.
I find it almost too beautiful to stare
at winter's soul laid bare.

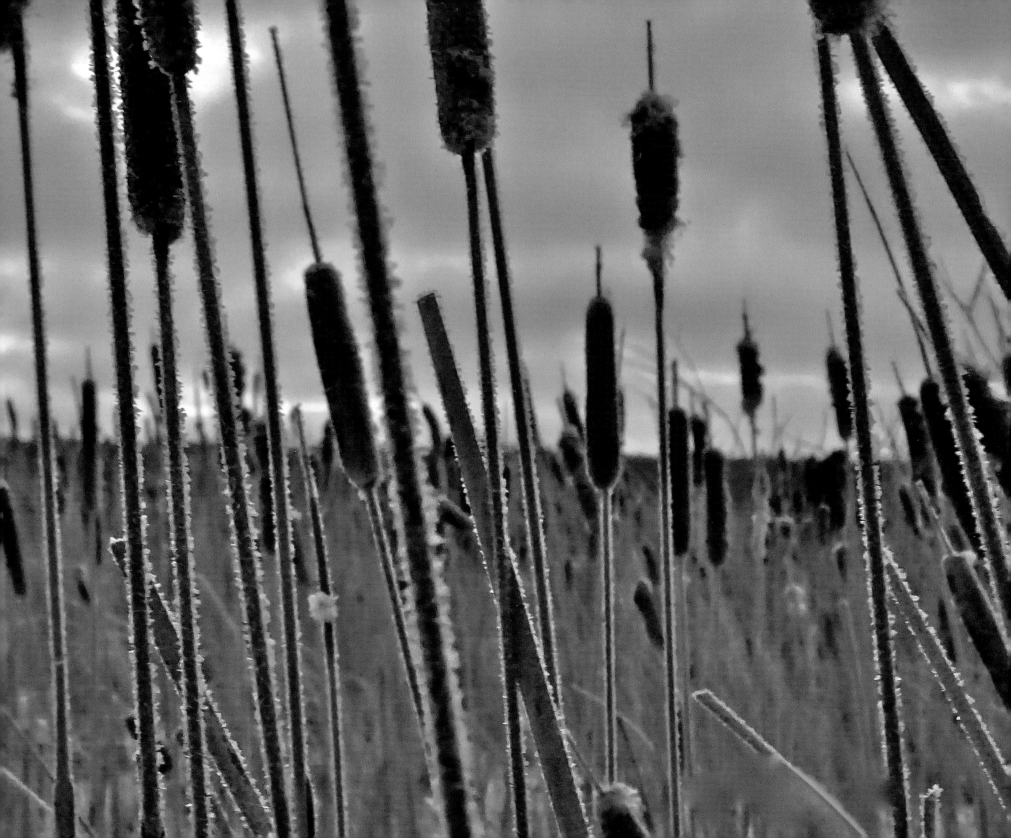

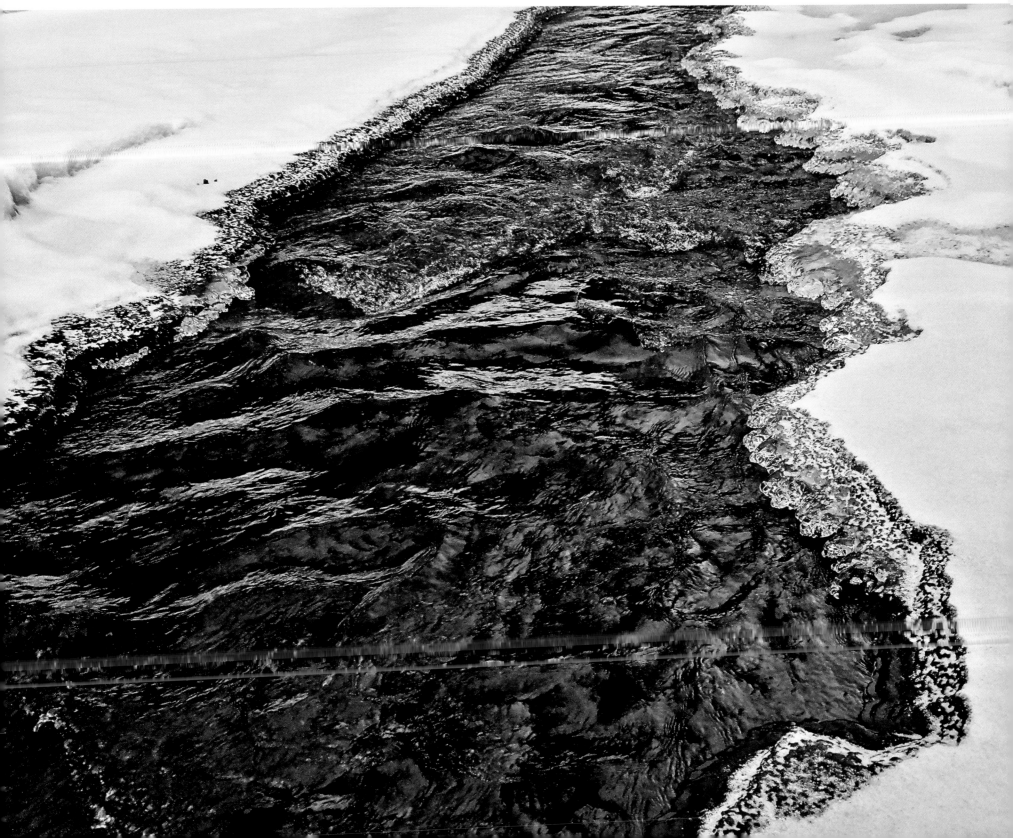

FINALLY HOME

Snowshoes plodding through the shadowy snow,
one foot after another I go.
Dogs by the woodstove faithfully wait,
I'll be back before sundown, never too late.
I follow the deer prints around the bend
to the abandoned shed where the tracks end.
Peeking through frosted windows I see,
forest spirits staring back at me.
Onward through the woods to a tiny hamlet scene,
home at last to the cabin of a long ago dream.

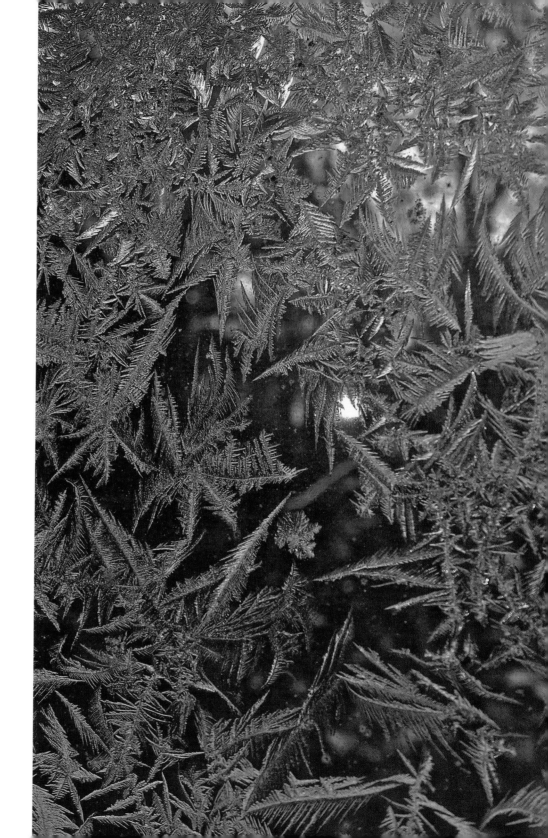

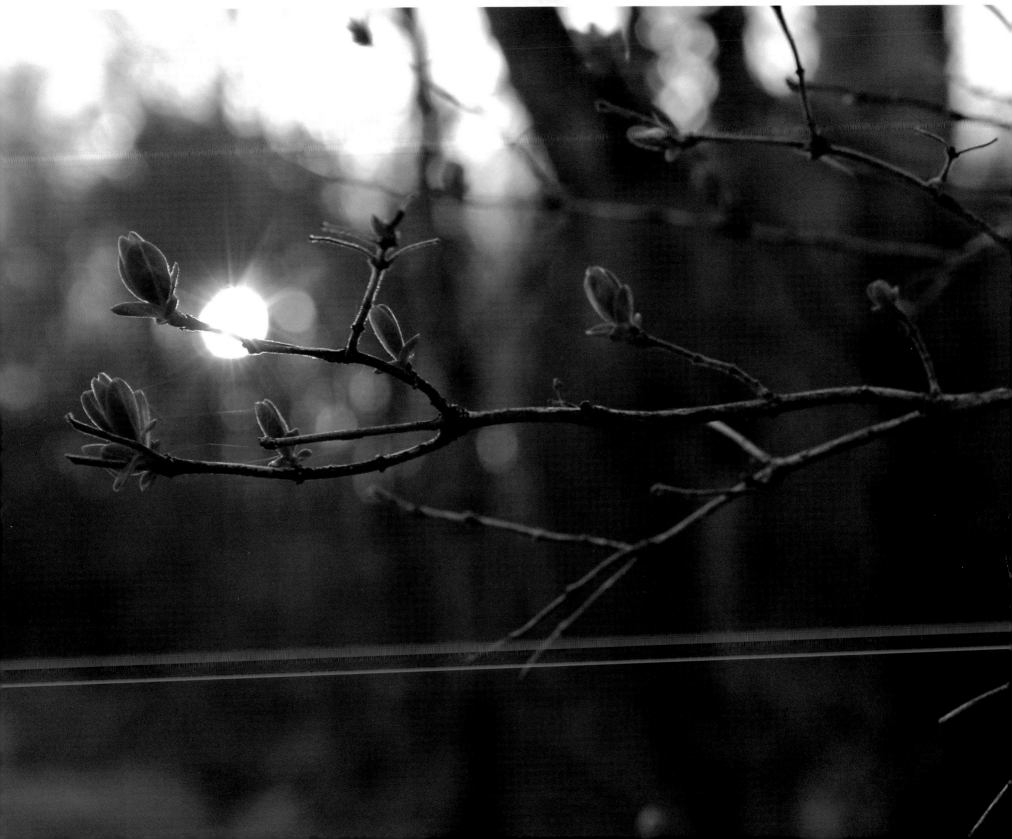

SPRING

ICE BOATS

Spring snow along the river's edge,
and sundrenched air so bright,
I hear whispers of wild iris growing under there.
Towers of iceboats drift ashore
like a little boy's building blocks left behind.
I breathe in spring's intoxicating air,
and watch the ice boats slowly melt along the river's edge.

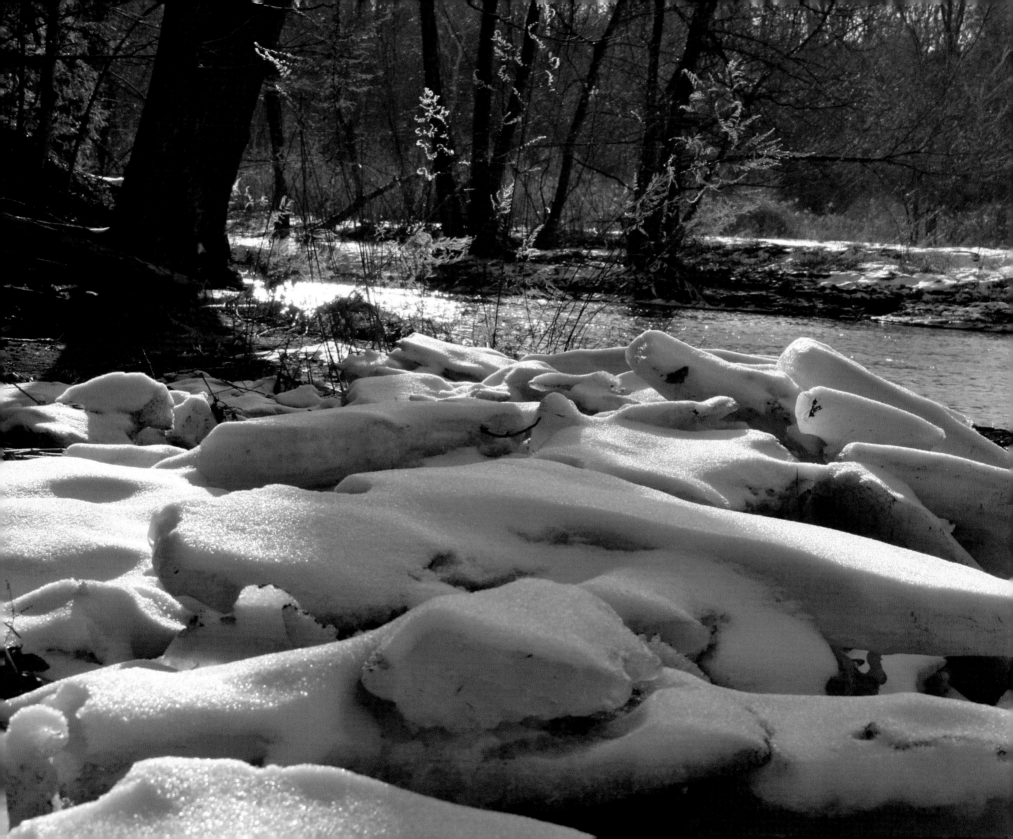

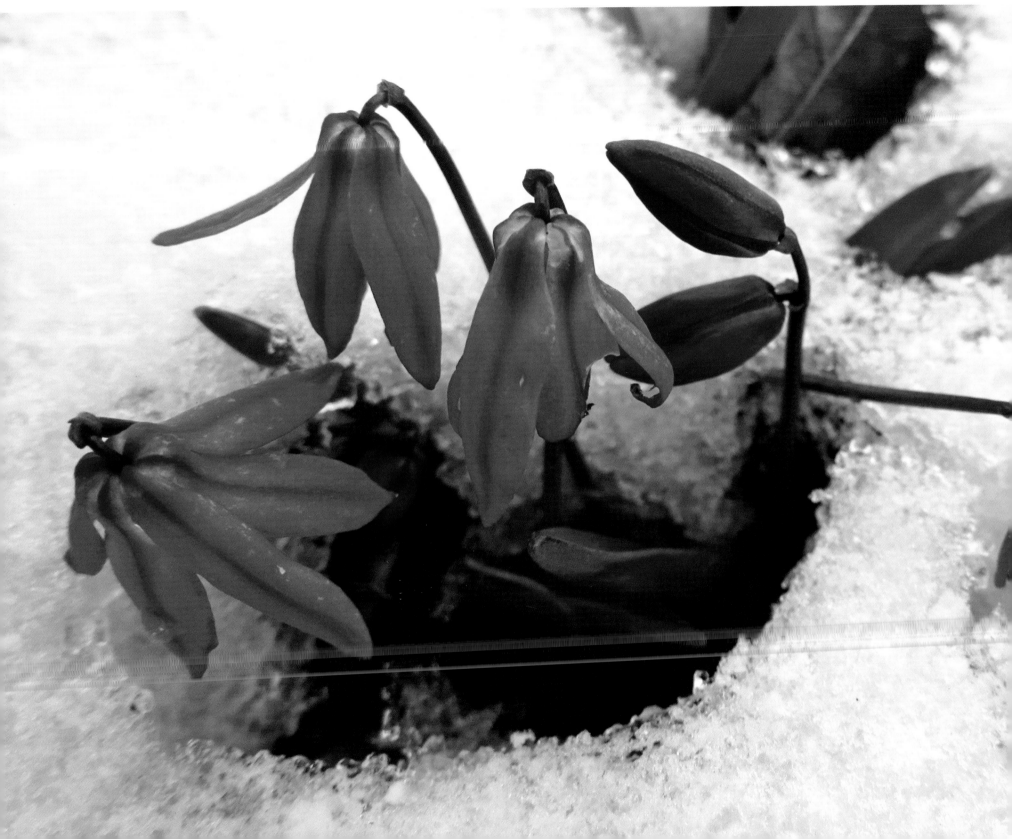

ODE TO A SIBERIAN SQUILL

When snow crystals begin to fade away,
you emerge like magic through winter's faded grass,
my delicate lady in fine blue-slippered feet.
Your head is bowed so tenderly,
I bend down to your exquisite face.
I feel a touch of sadness
knowing that of this bloom soon there will be no trace.

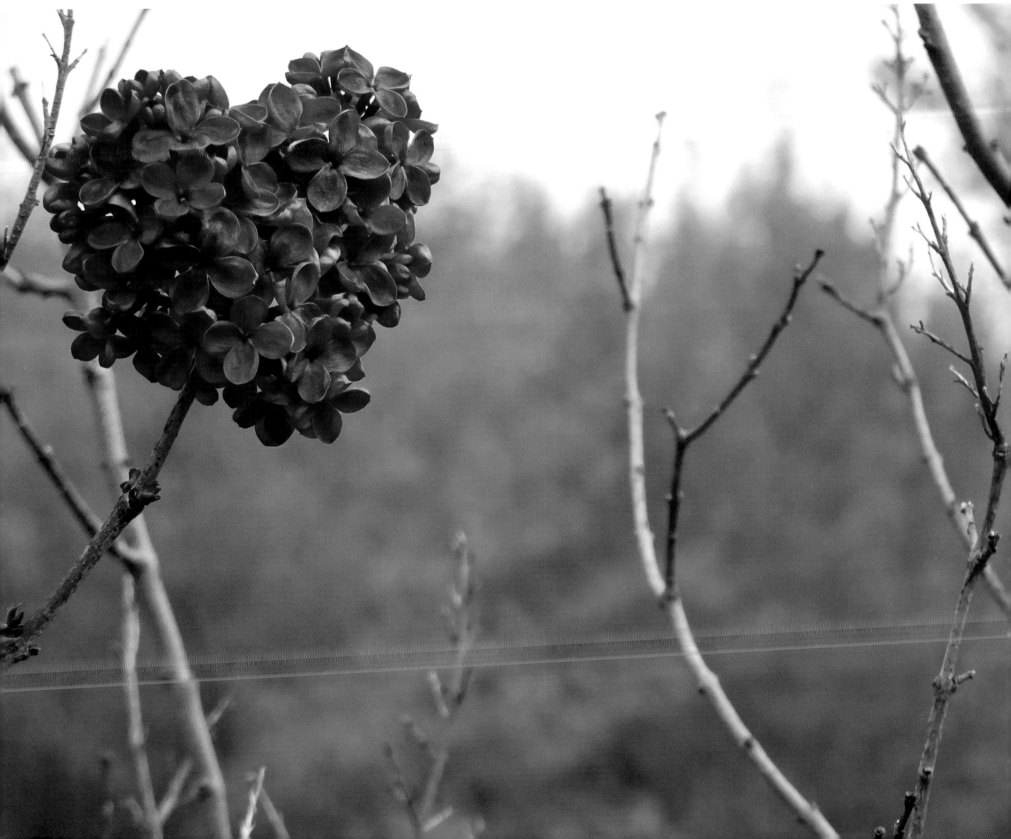

THE NIGHTSTAND

There were little rainbows on the wall
as the sun caught the edge of the crystal vase
where lilacs held center stage on Mom's nightstand in May.
The books were stacked high to make room for yet one more.
Passing by a neighbor's barn,
the lilacs in full bloom,
I breathe them in and travel back
to visit Mom in May.

SILHOUETTE OF HISTORY

Smooth, bleached wood absorbing the rising sun,
muted grays whispering of rainclouds
and shadows of twilights past.
I listen to the baby owlets you harbor
selflessly within.
A silhouette of history,
in death still beautiful,
adorned by a skirt of wild pink blossoms.
I stop and bow.

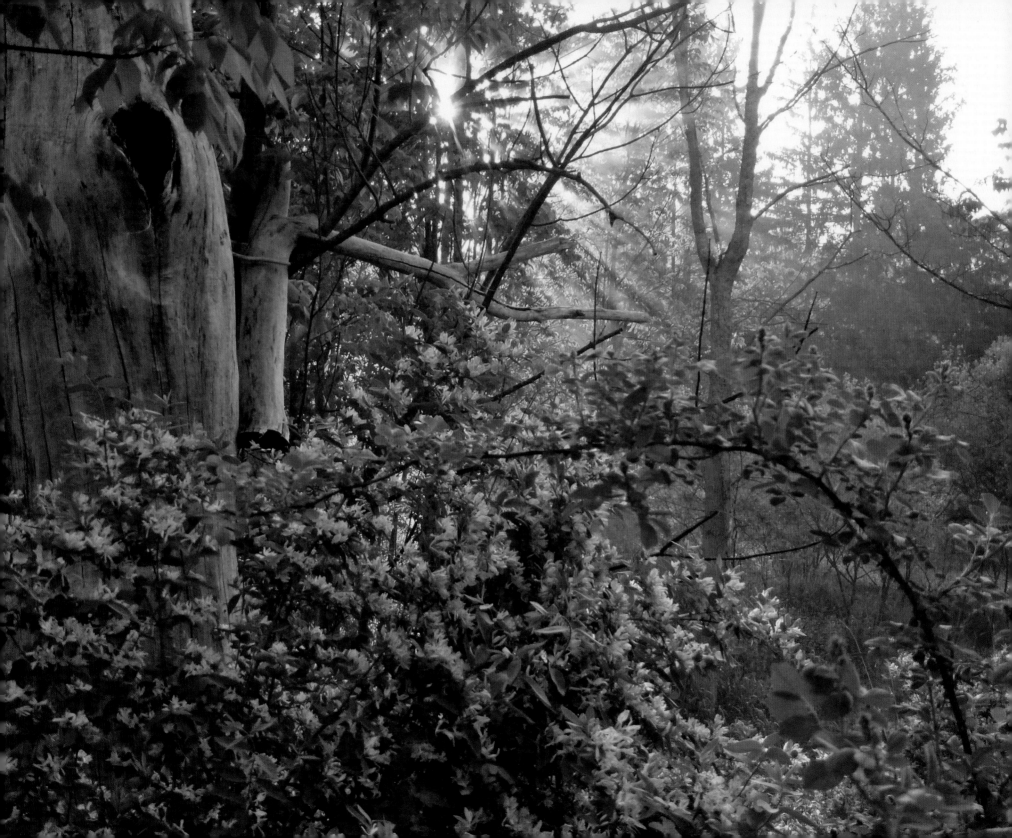

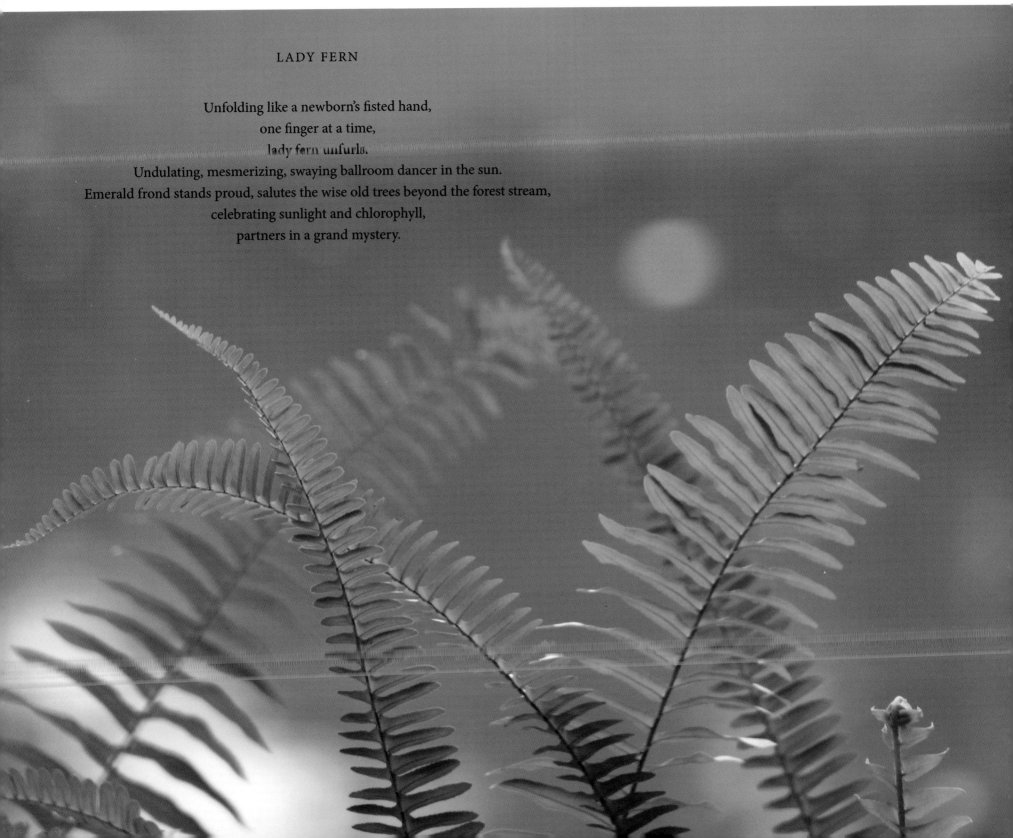

LADY FERN

Unfolding like a newborn's fisted hand,
one finger at a time,
lady fern unfurls.
Undulating, mesmerizing, swaying ballroom dancer in the sun.
Emerald frond stands proud, salutes the wise old trees beyond the forest stream,
celebrating sunlight and chlorophyll,
partners in a grand mystery.

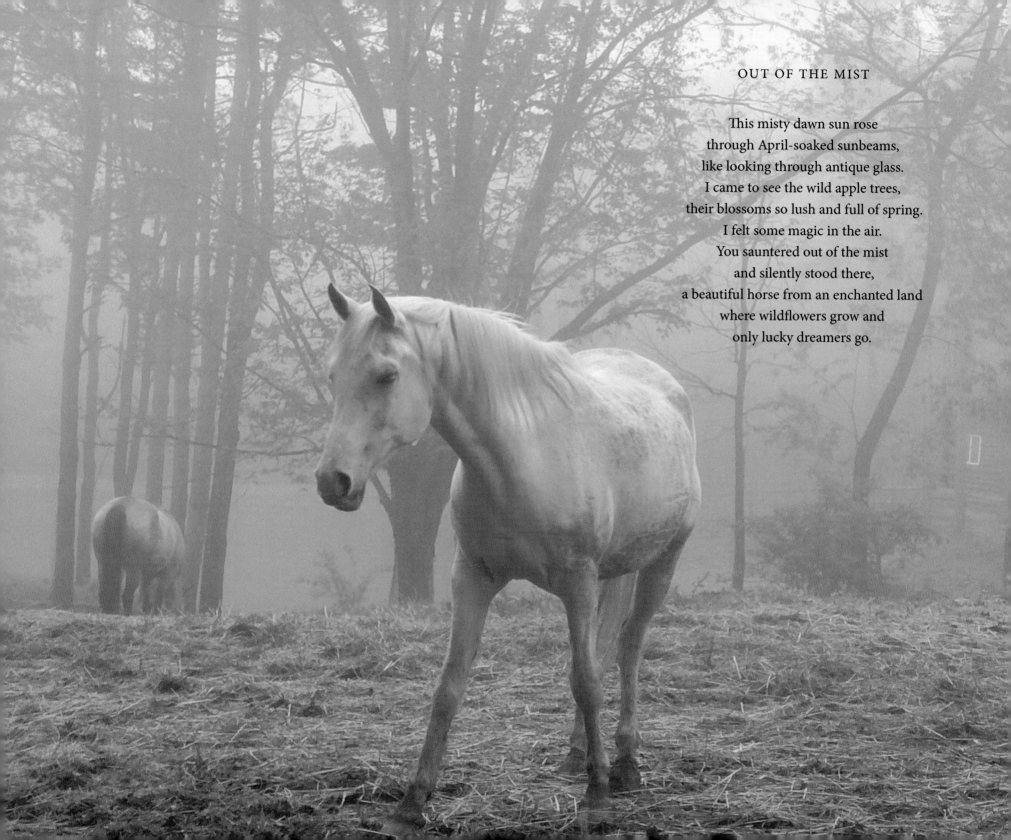

OUT OF THE MIST

This misty dawn sun rose
through April-soaked sunbeams,
like looking through antique glass.
I came to see the wild apple trees,
their blossoms so lush and full of spring.
I felt some magic in the air.
You sauntered out of the mist
and silently stood there,
a beautiful horse from an enchanted land
where wildflowers grow and
only lucky dreamers go.

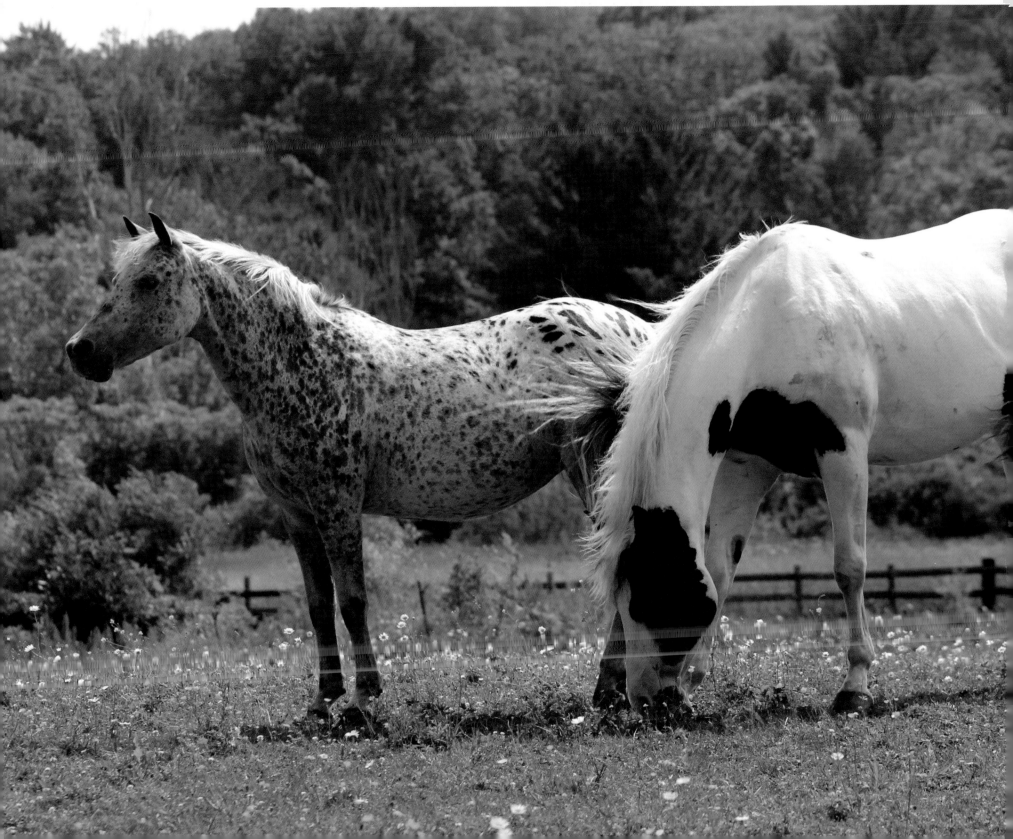

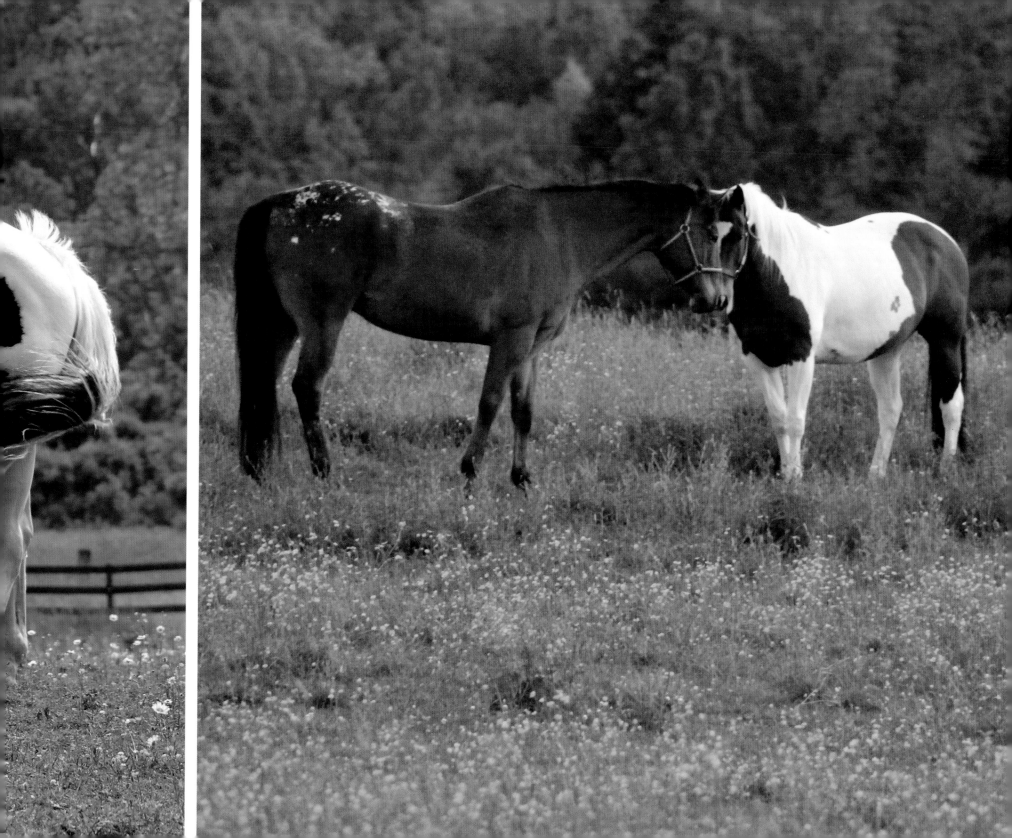

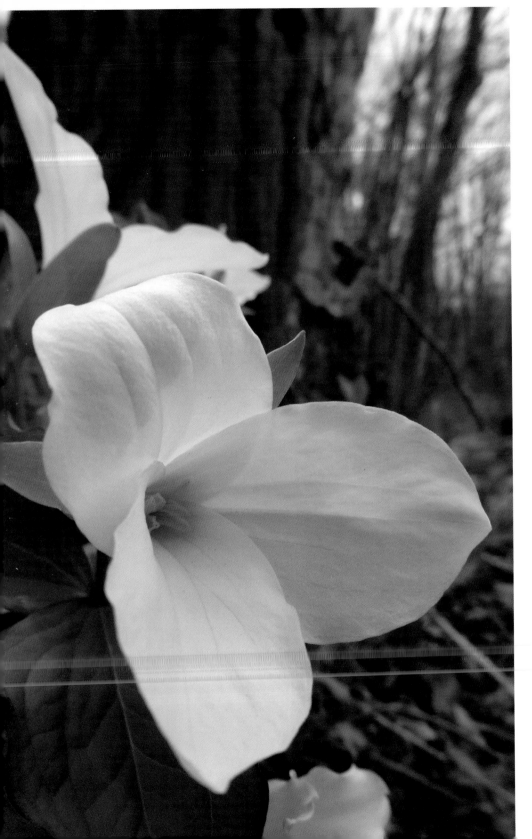

TRILLIUM PROMISE

Waiting underground, a spirit under drifts of snow.
Labored and pressured and fearful in the dark cold.
Endless winter, black, numb, and silent.
And then, in a great thrust of hope,
through rotting, wind-blown leaves and softening earth,
your spirit evolves in perfection.
Three perfectly-formed white petals with a golden center
reach towards the long-awaited sun.
Purity, grace, renewal.
Spring's sweet, sweet beginning.

THE SEED

Shimmering seed still unsown
like a thought floating by,
from where I do not know.
I sense you have a distance yet to go.
I am grateful to have noticed you,
little seed, yet unsown.

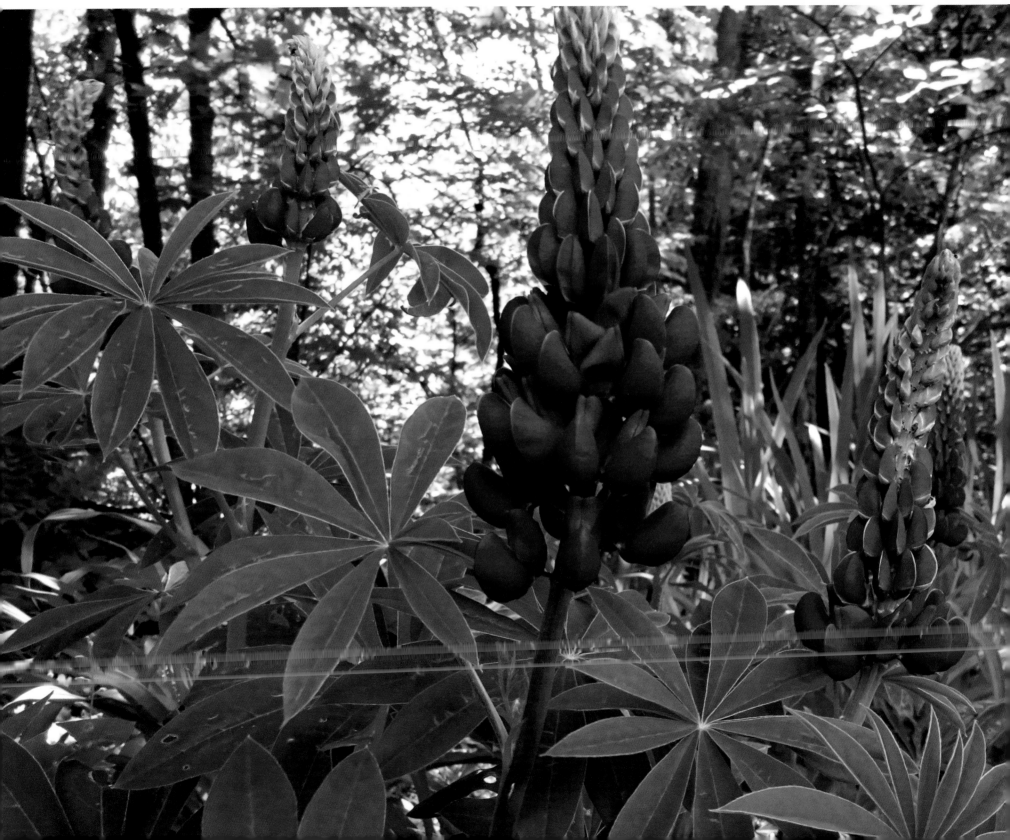

LUPINES

Oriental fans opened wide,
the finest shade of jade.
I stand transfixed among the
feathery ferns where the lupines grow.
Rich, deep shades of amethyst,
standing erect, purple cadets,
lupines in nature's garden grow.

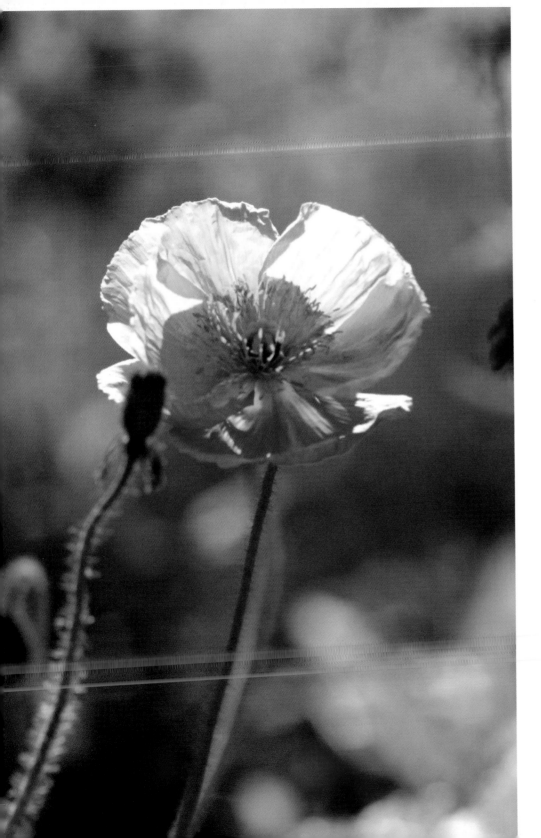

PAPER LANTERNS

Pink light through poppy petals' glow,
as if you were a paper lantern, your new blossoms grow.
I walk in the garden and feel the earth soft beneath my feet.
The world feels new, like a promise kept between best friends.
Pink light through your poppy petals glows.

CHASING DEWDROPS

Day is new and all is still.
The sun is poised and soon to rise,
an orchestra of birds prepares to sing their morning song.
It is then that I must go to find the gifts of dawn,
like sunshine on dewdrops clinging to daisies,
an iridescent feather in the grass, or a newborn fawn.
I know it is my calling, and has always been,
heading out at first light and
chasing dewdrops in the sun.

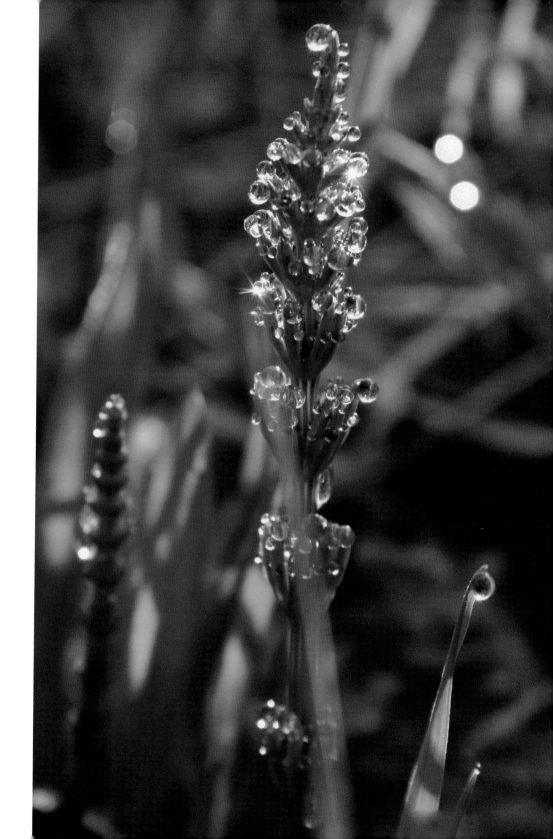

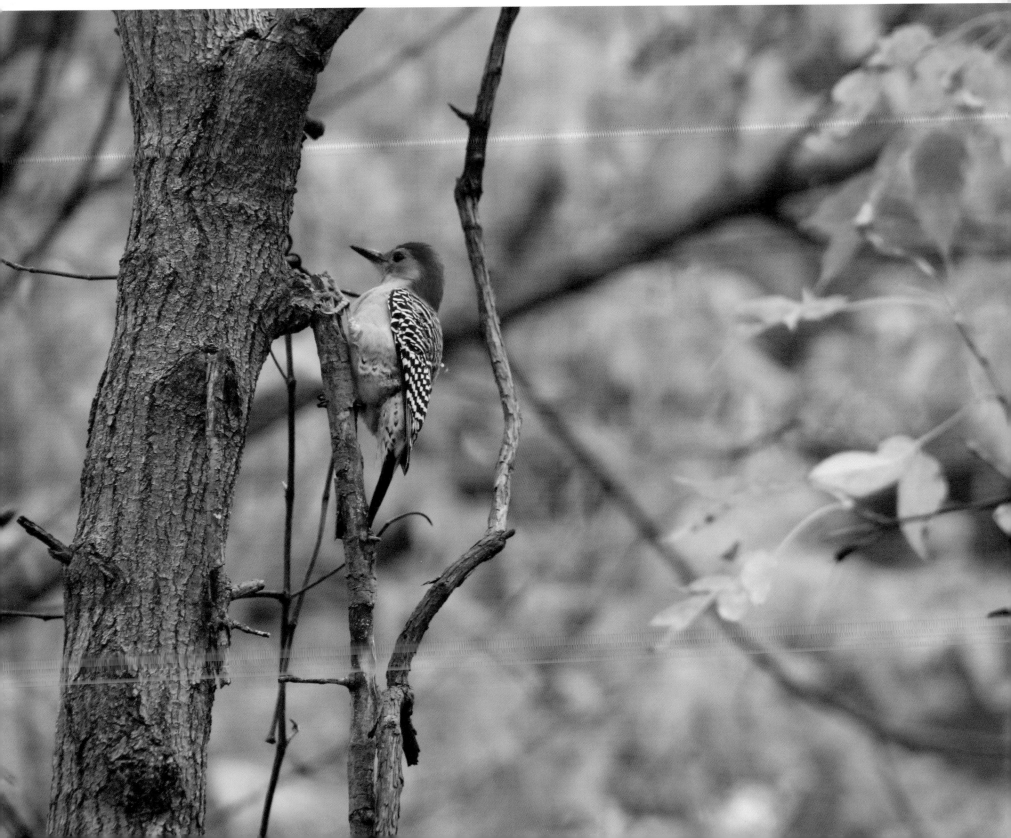

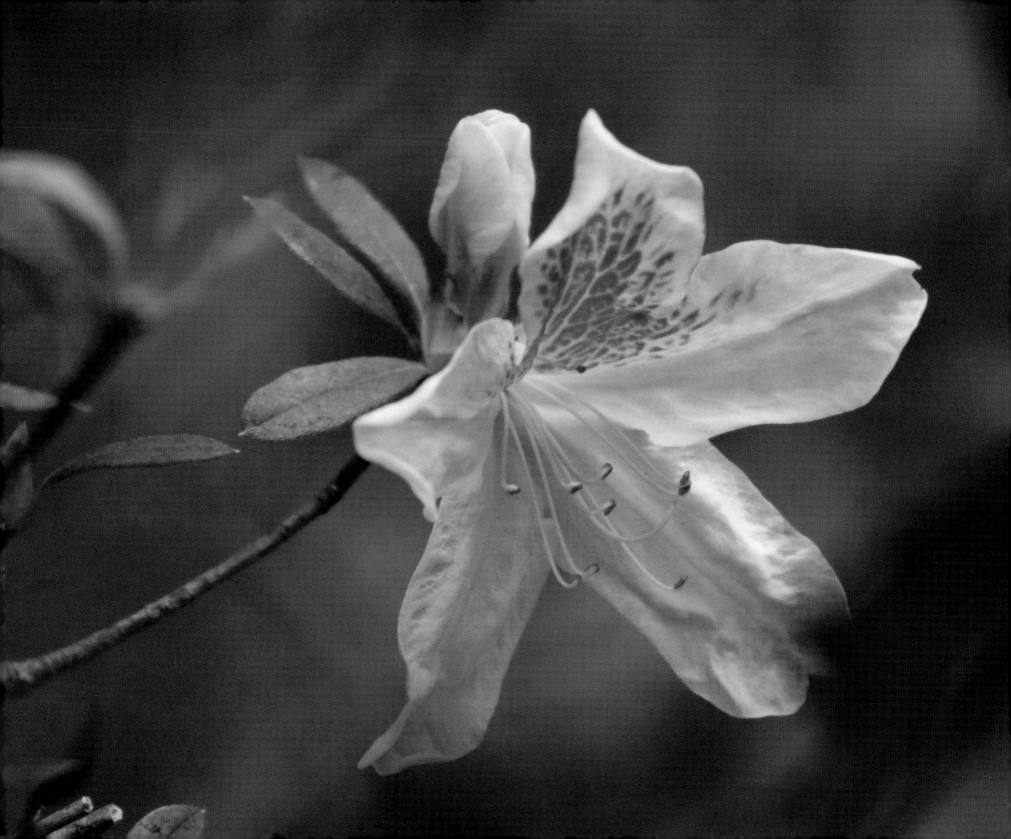

TULIP SOUL

Morning sun cast a spell upon your face.
I gaze in wonder as far as my eyes can see
into the infinity between petals where
the spirit of spring resides
and colors are born.

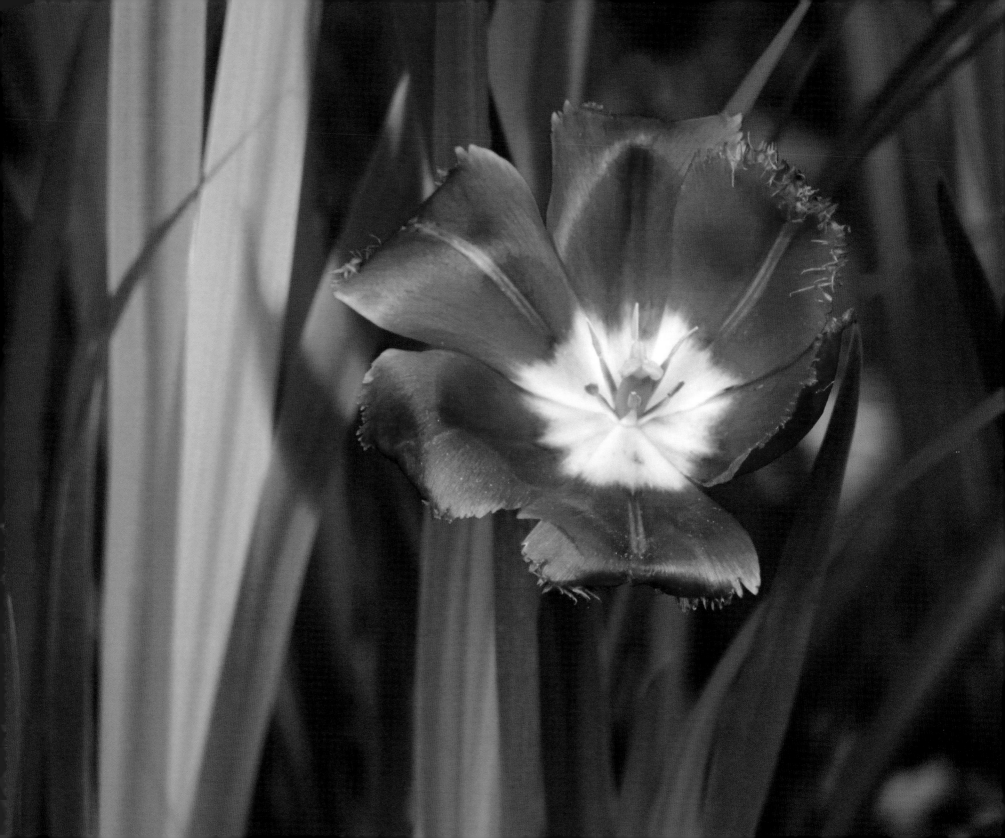

SONG OF THE HERMIT THRUSH

I set out walking with a route in mind
that meanders past a row of pines and circles 'round the horse farm.
There is a dark brown horse there with a white star on his velvet nose,
who holds his head high when I pass by.
Then my heart stirs to a hermit thrush song, a spring phrase so sweet.
I trail after your notes down the ravine at the forest's edge and listen
as your trill joins the water song of snow melt,
and realize you have led me home.

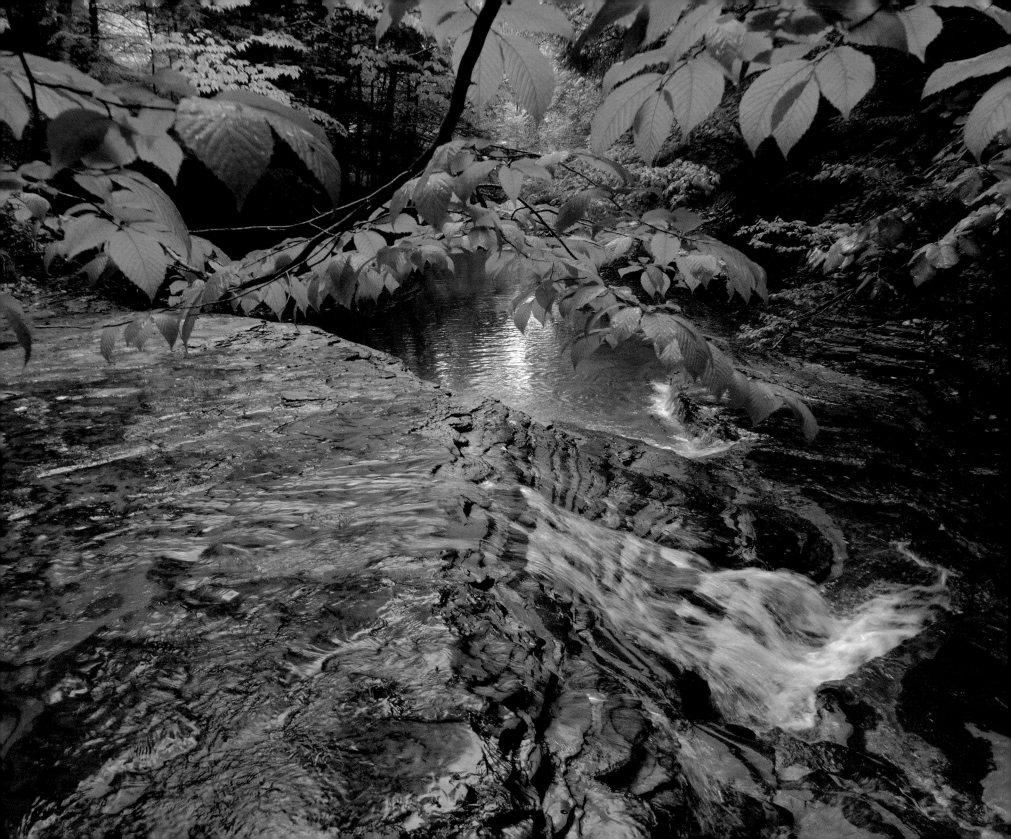

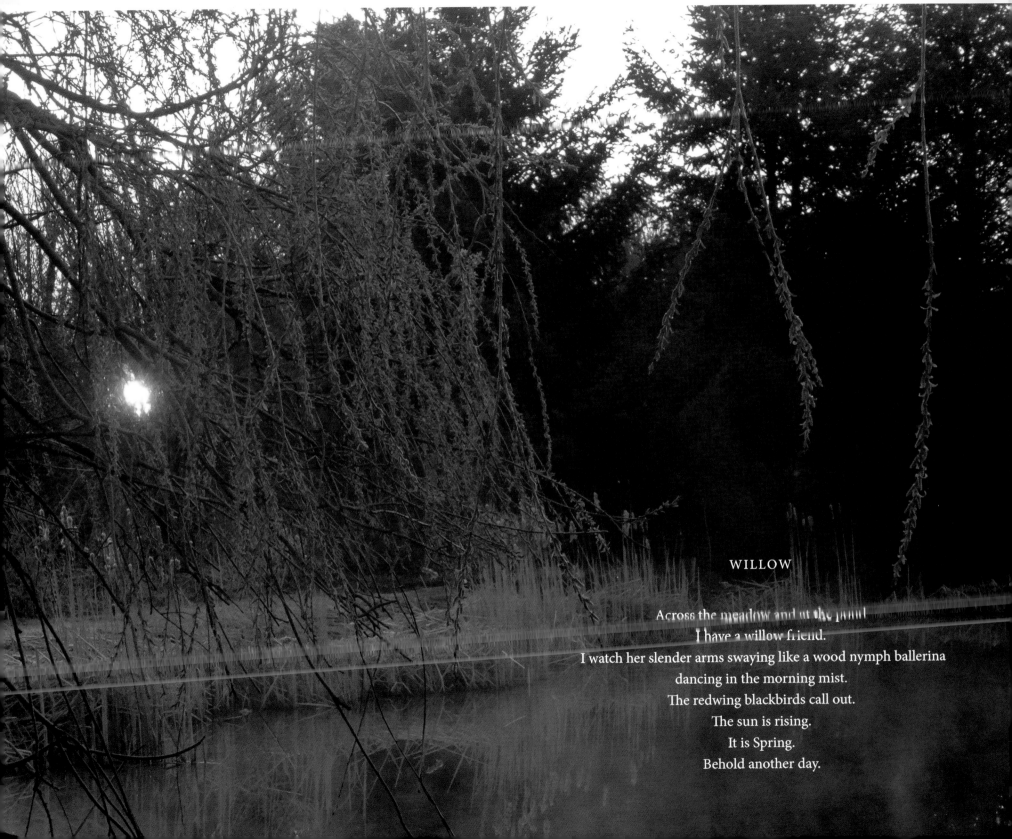

WILLOW

Across the meadow and at the pond
I have a willow friend.
I watch her slender arms swaying like a wood nymph ballerina
dancing in the morning mist.
The redwing blackbirds call out.
The sun is rising.
It is Spring.
Behold another day.

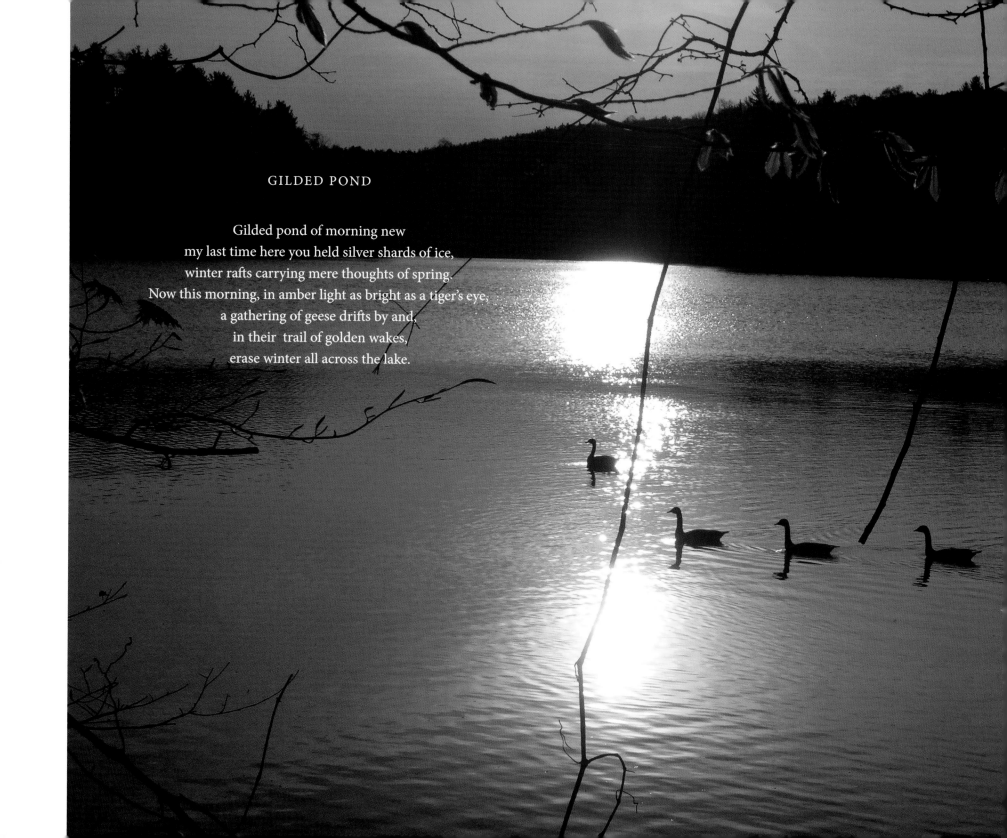

GILDED POND

Gilded pond of morning new
my last time here you held silver shards of ice,
winter rafts carrying mere thoughts of spring.
Now this morning, in amber light as bright as a tiger's eye,
a gathering of geese drifts by and,
in their trail of golden wakes,
erase winter all across the lake.

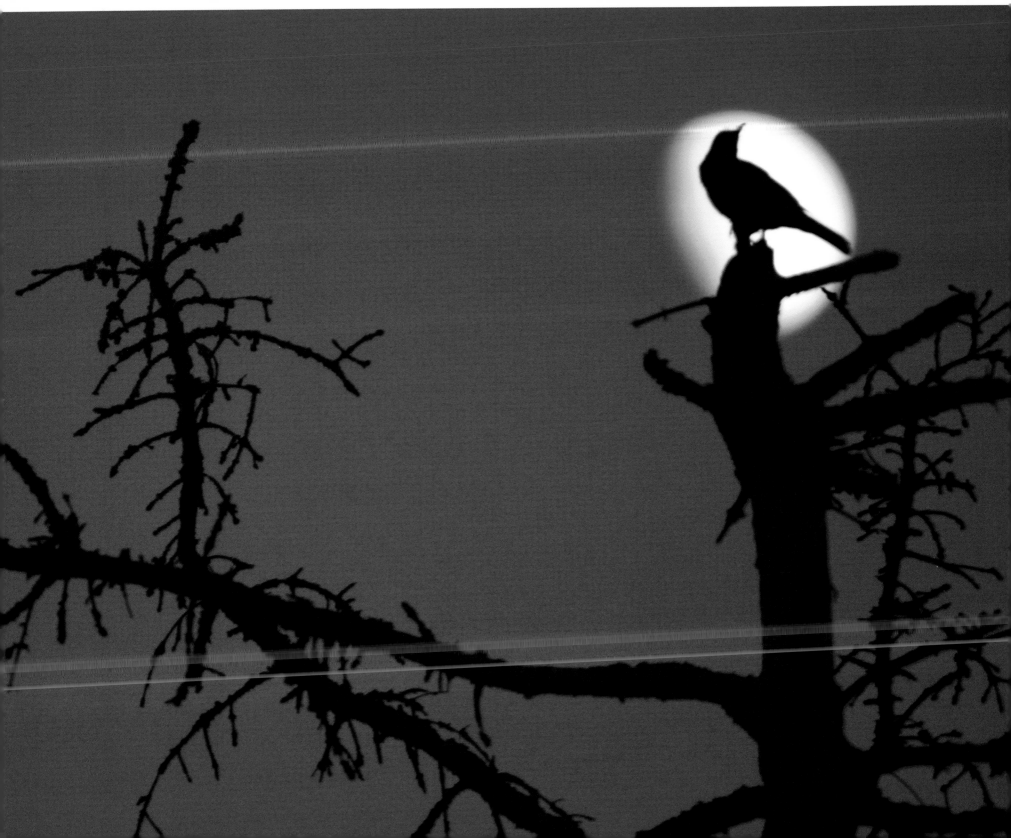

TWILIGHT TREE

Walking at moonrise through the silent symphony of shifting clouds
and shuffling stones,
I hear silver grey notes from the twilight tree,
where birds gather to whisper in treble clef their evening prayer.
A blackbird roosts at the end of the day
as the moon ascends in the sky,
and all the world stands still.

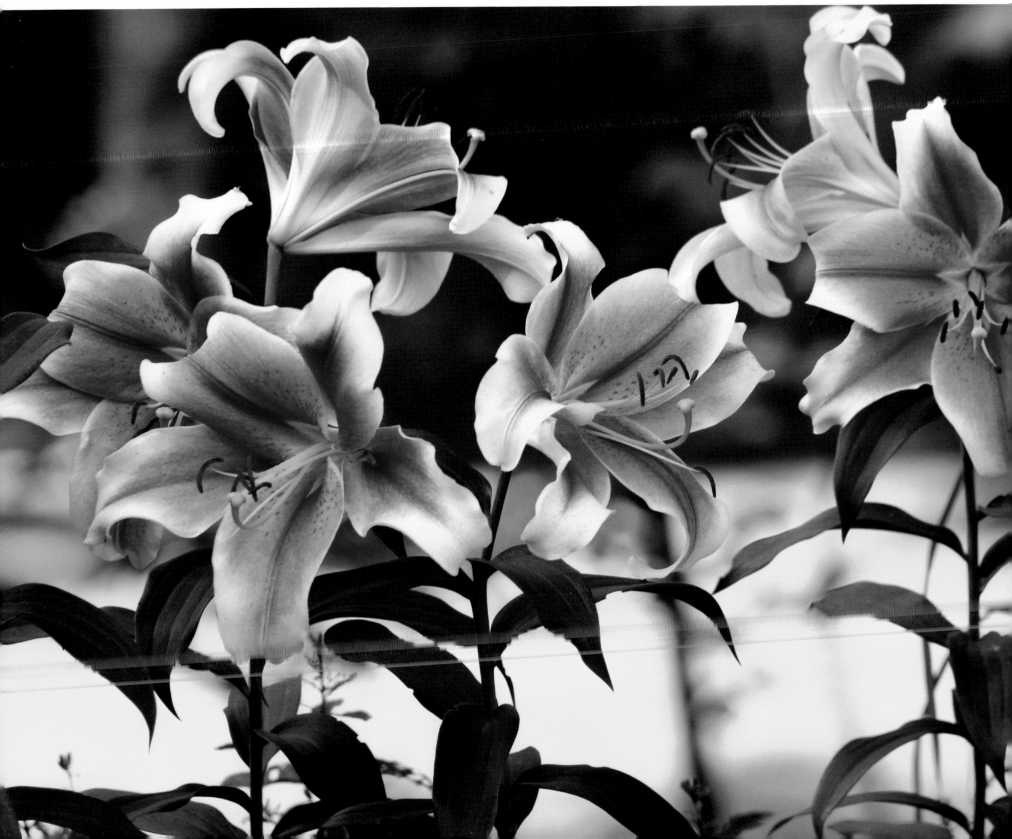

SUMMER

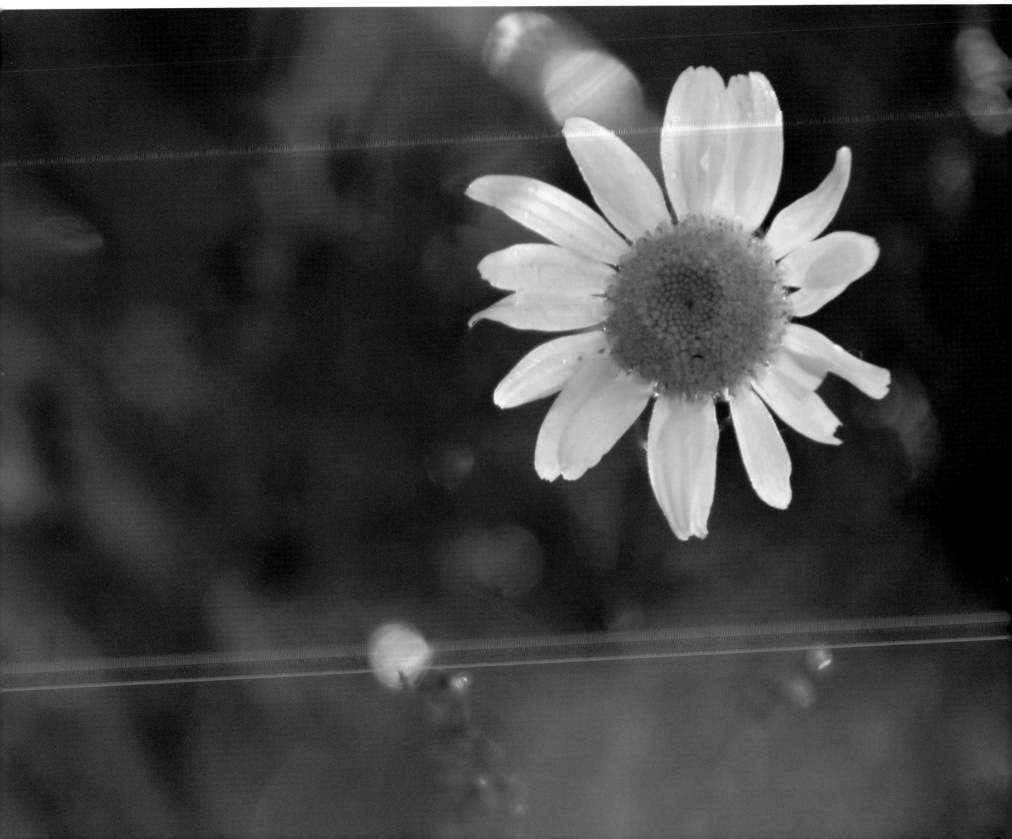

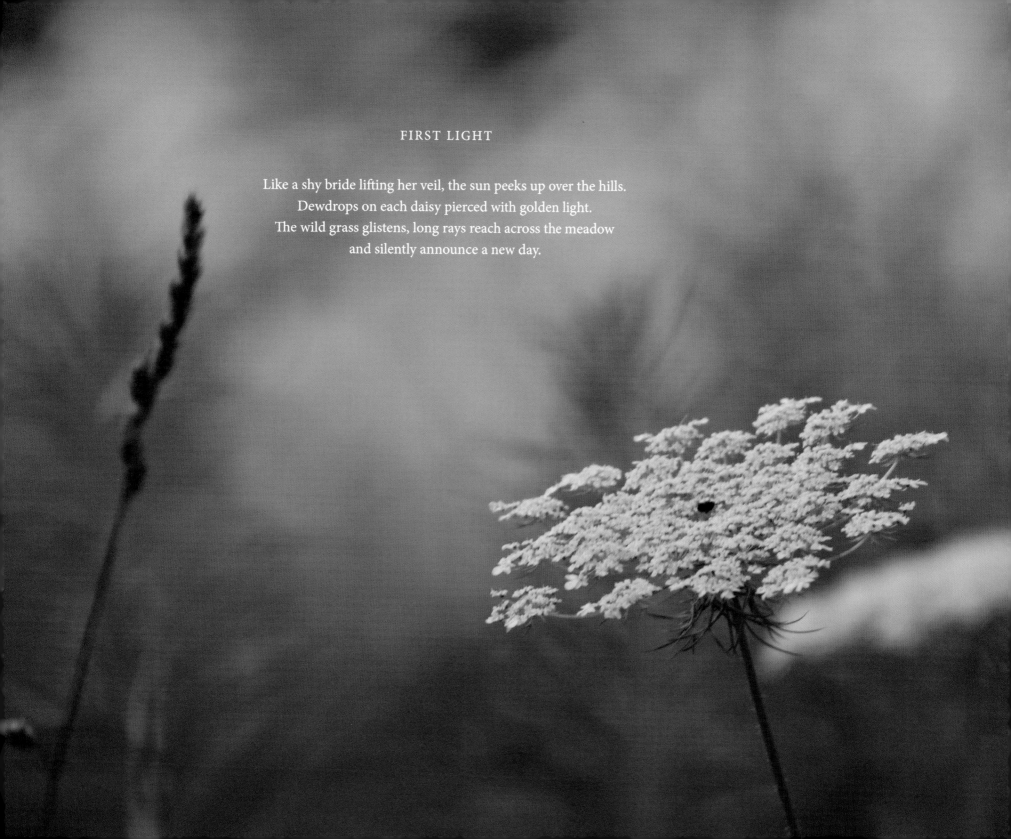

FIRST LIGHT

Like a shy bride lifting her veil, the sun peeks up over the hills.
Dewdrops on each daisy pierced with golden light.
The wild grass glistens, long rays reach across the meadow
and silently announce a new day.

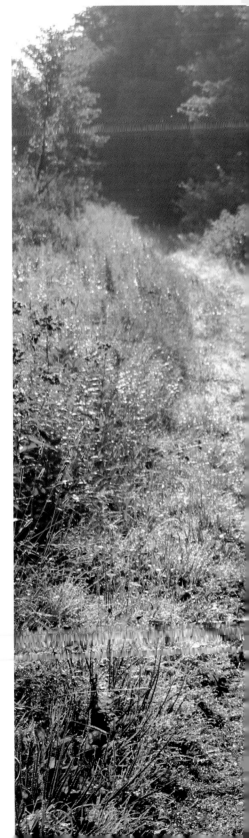

NO DESTINATION

I go in search of wildflowers with no destination in mind.
It is then that I am most likely to find
deer trodden paths lined in pink,
and wild grasses welcoming me in.
Slowly, so slowly I enter,
the crickets chirp and chatter,
nothing pressing seems to matter,
when I go with no destination in mind.

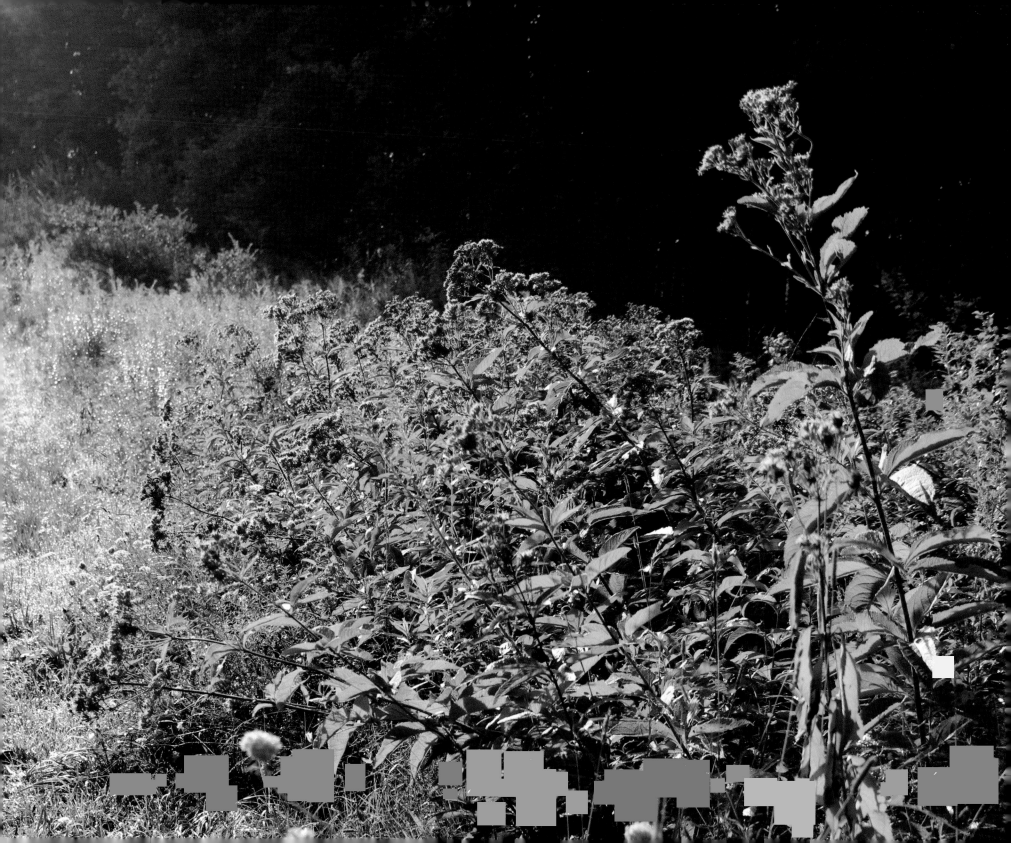

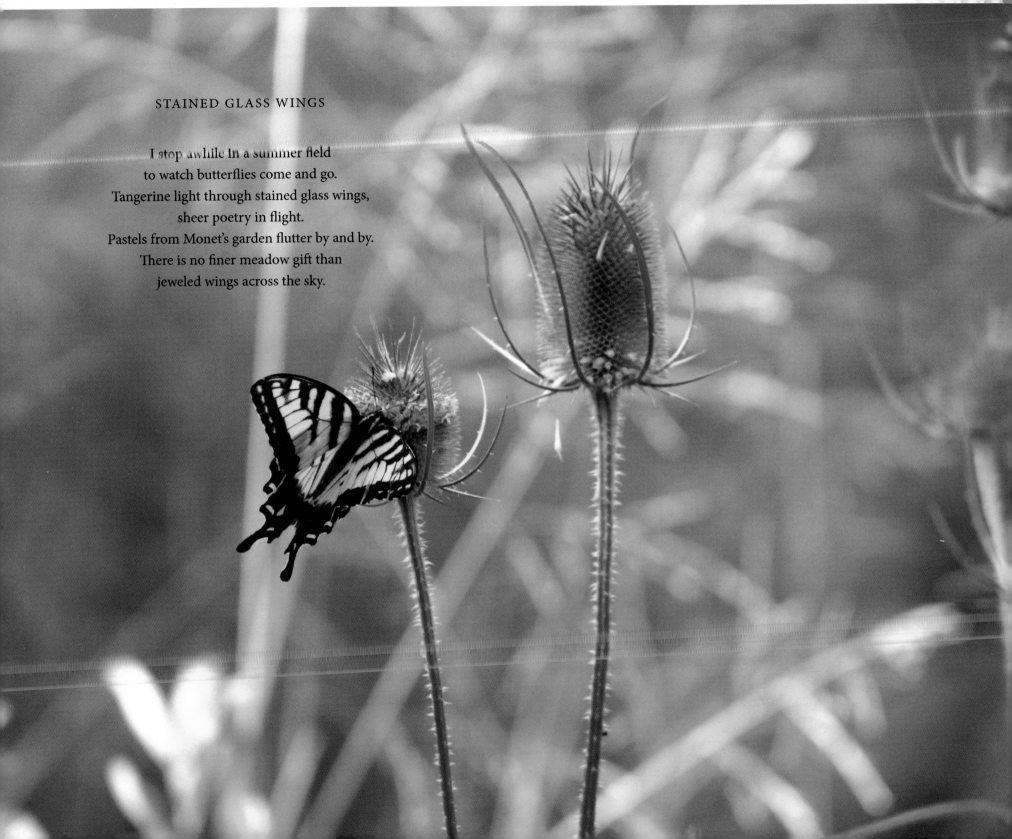

STAINED GLASS WINGS

I stop awhile in a summer field
to watch butterflies come and go.
Tangerine light through stained glass wings,
sheer poetry in flight.
Pastels from Monet's garden flutter by and by.
There is no finer meadow gift than
jeweled wings across the sky.

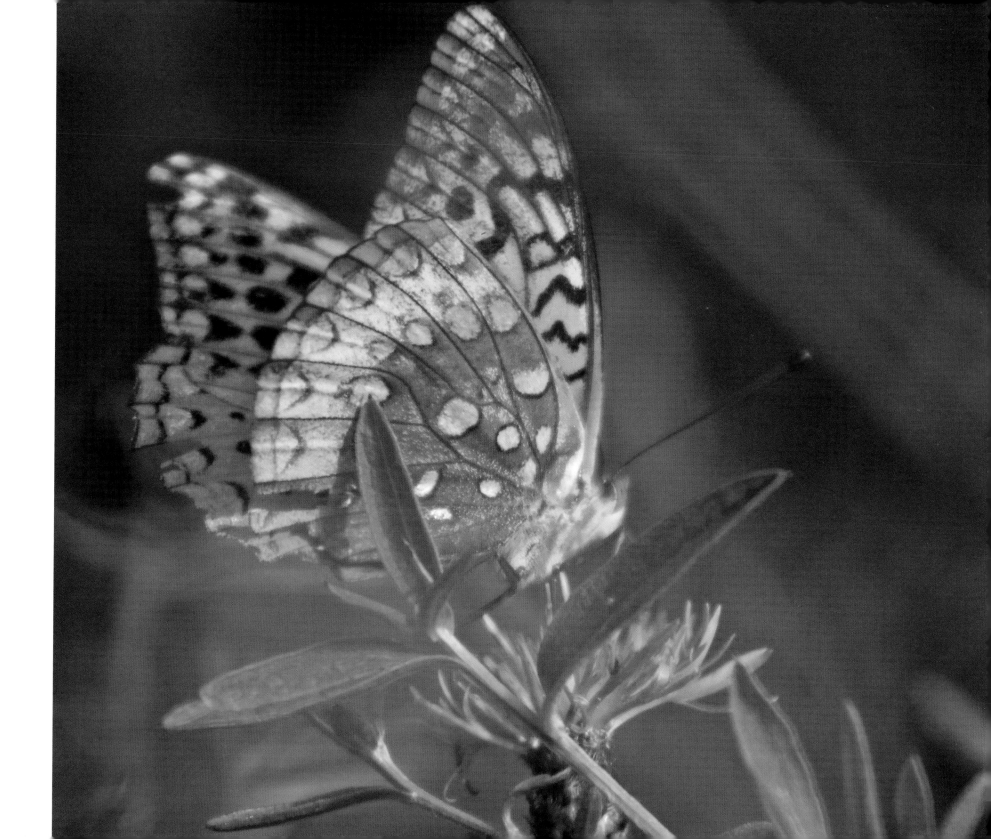

LADY BOAT

River sprite upon your shimmering pink boat,
may I join you for just one ride?
We'd float past sunbeams and a concert of frogs,
across the pond we'd glide
stopping to sun by the old oak log.
Dear sweet river sprite, may I book a ride?

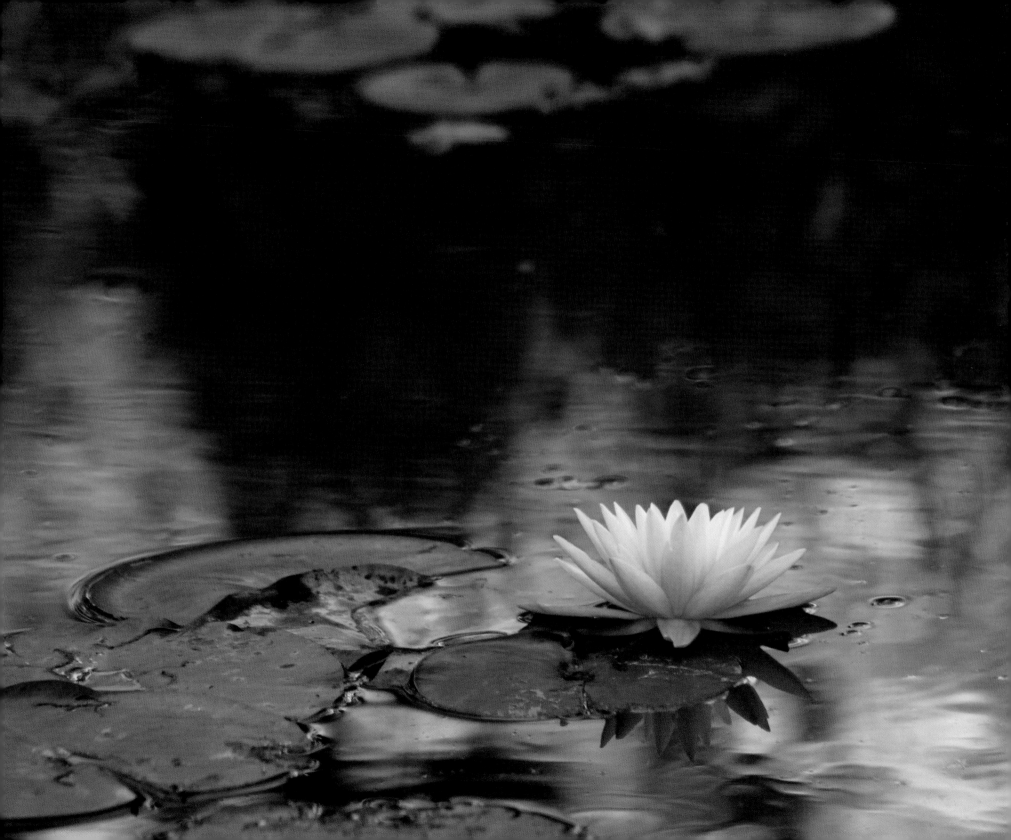

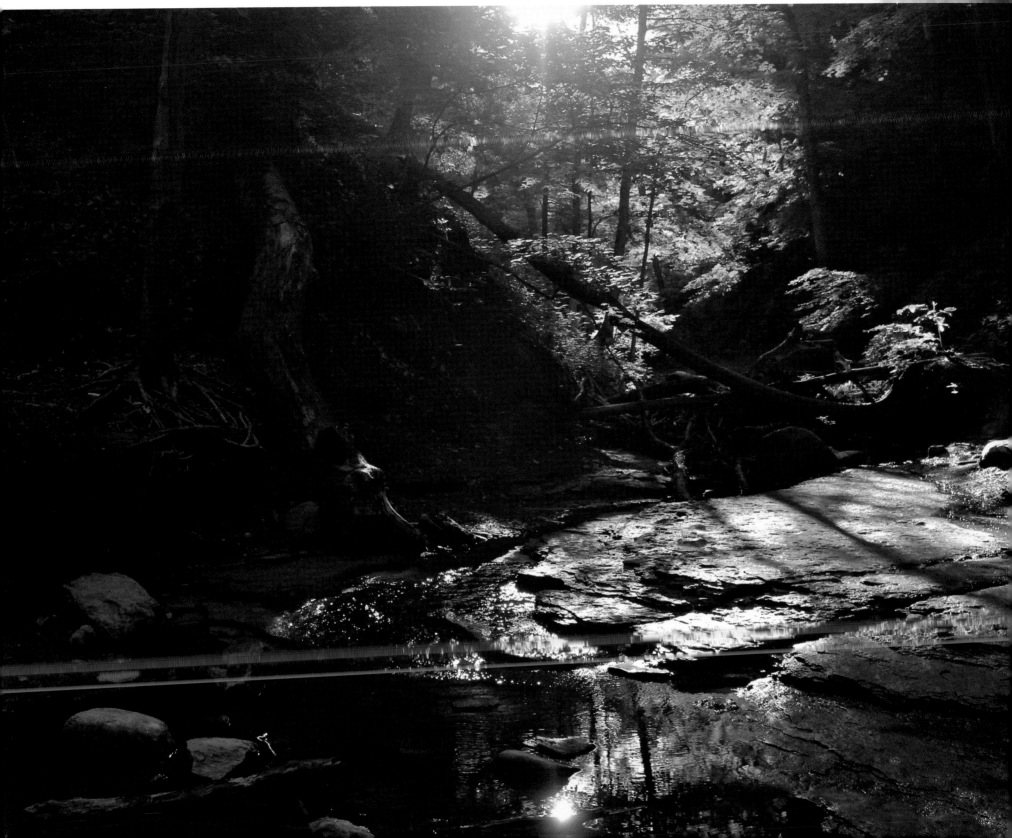

THE RAVINE

The raw beauty of ancient rock beckons.
I weave through roots, listening for water.
Descending lower and lower,
the ravine calls…
Off-trail hiking through sun-splashed spray,
into a hidden crevice as the sun rises over the east rock wall.
I rest and listen to the concert of the waterfall.

PEARLS OF DAWN

Enchanted pearls of dawn,
balanced between branches of delicate pine.
On a single strand of spider web,
you reveal the perfection of nature's design.
Elegant necklace of dew,
entirely divine.

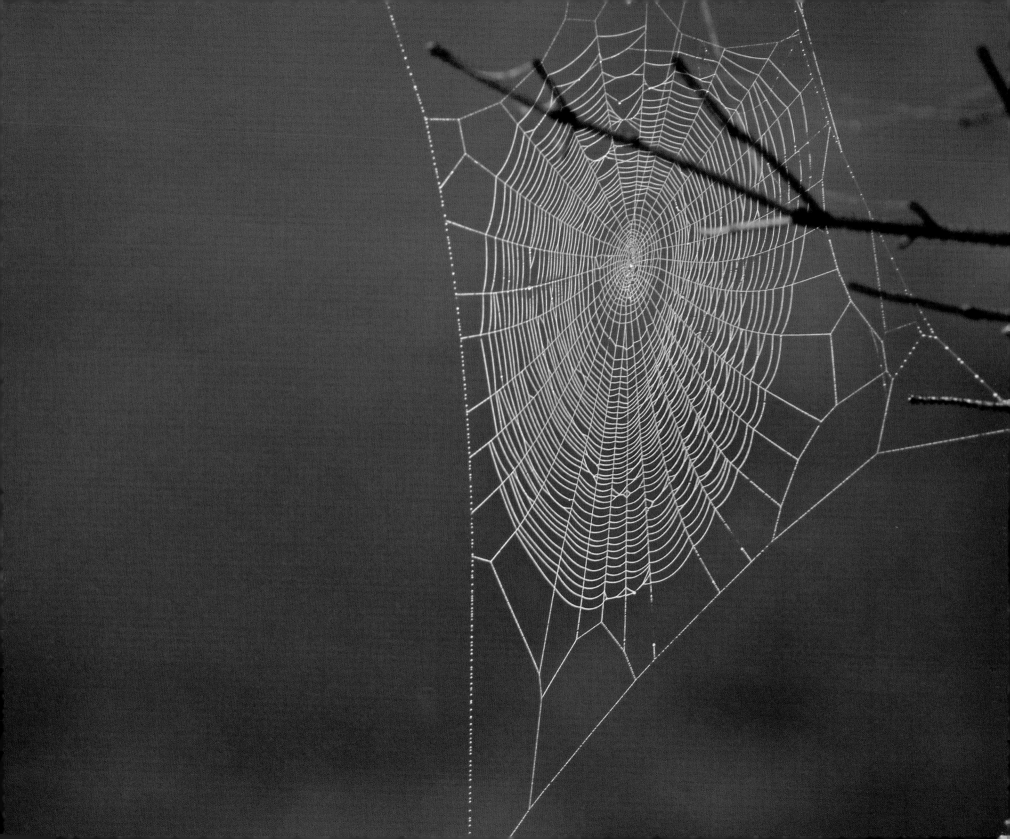

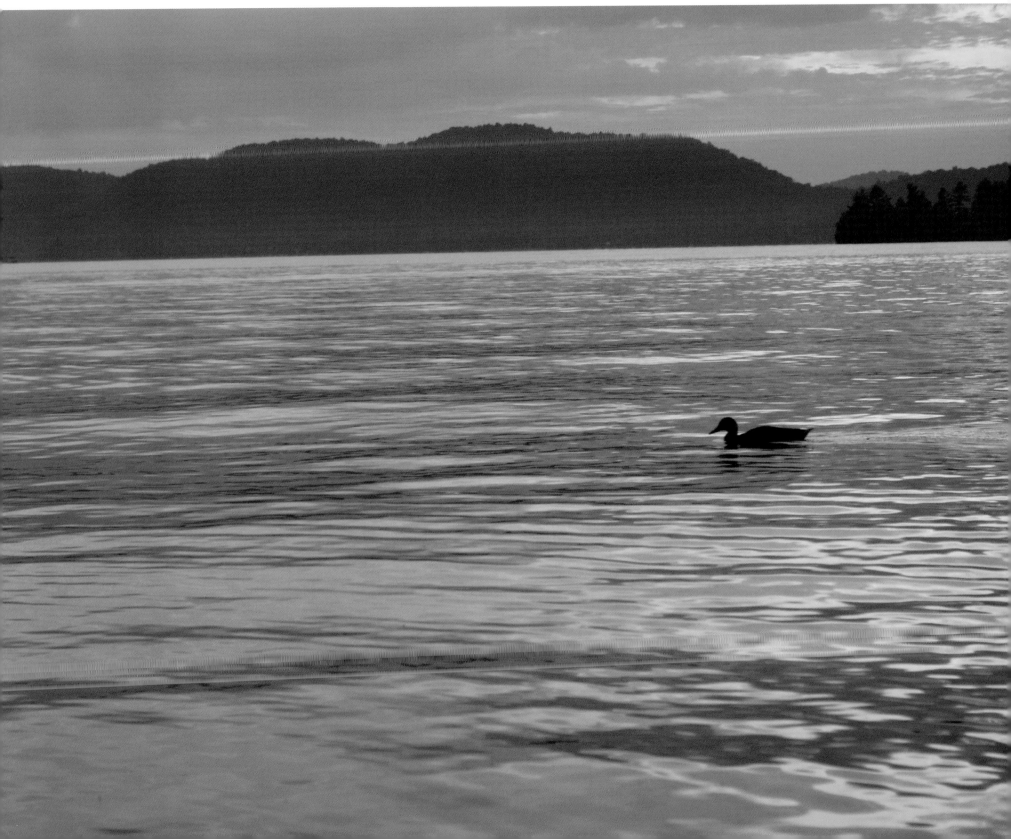

WINDCHIMES AND WAVES

A fragrant lily breeze greets me this lakeside morn.
Windchimes stir a song of summer air,
holiday time without a care.
Waves lap gently on the worn old dock.
I sit with a fresh cup of coffee and watch the ducks paddle by.
I'll cherish this blissful moment the rest of my days.
A perfect lakeside morning of windchimes and waves.

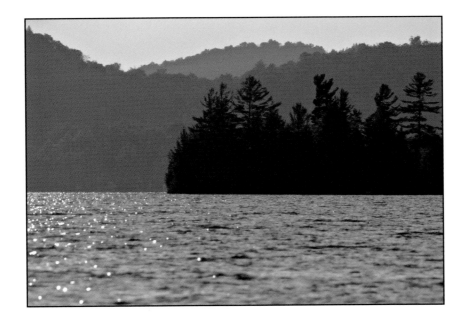

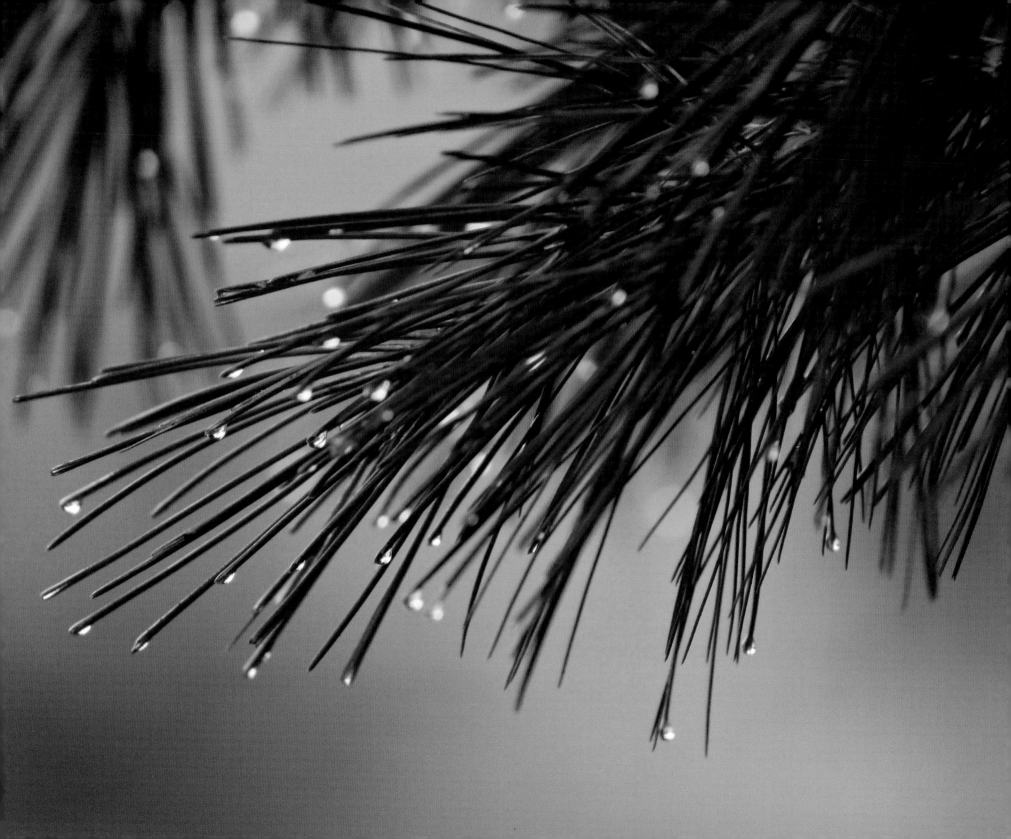

WEATHERED WOOD

What is it about weathered wood that calls my soul?
Forgotten lofts where mourning doves rest their wings,
the cooing sounds, the smell of hay and other country things.
Walking at sunset, the world feels soft.
Dusk pink clouds have tucked in the barn,
the old farm horse at rest in his stall,
the rooster all settled in his pen.
No sounds to be heard until
dawn when the raven calls again.

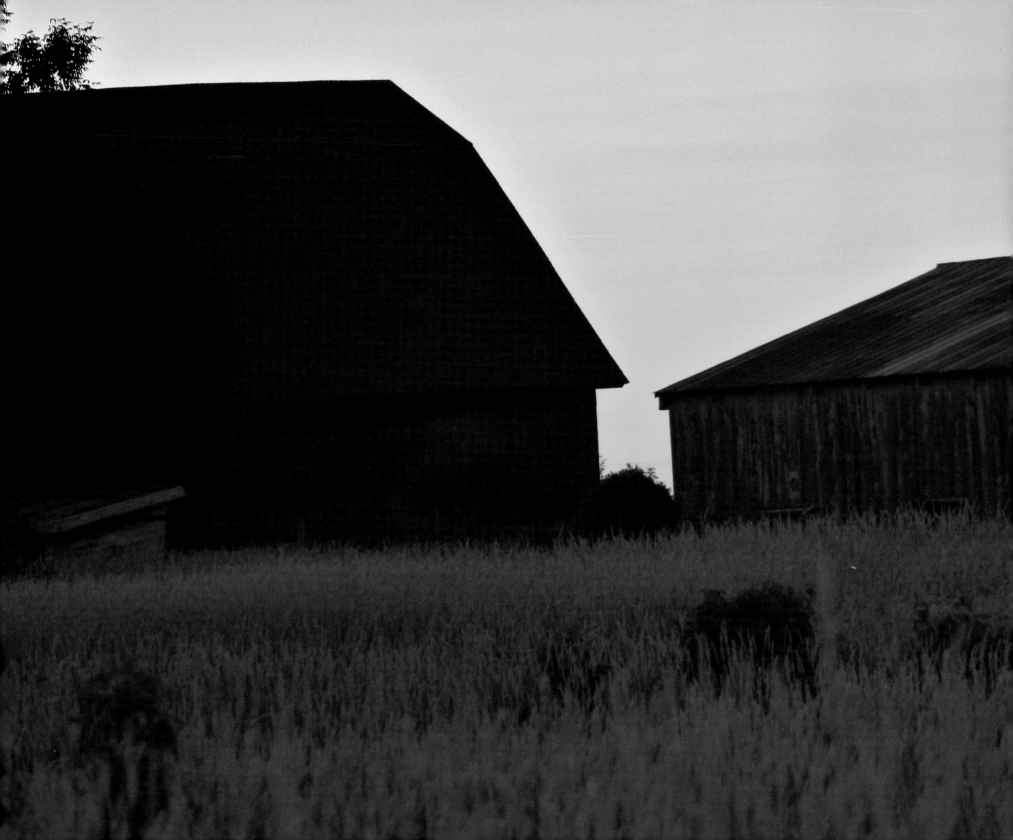

AUTUMN

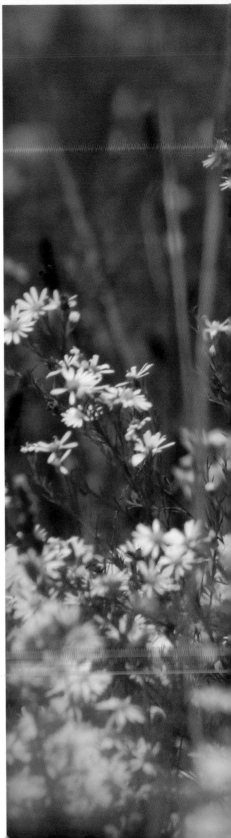

RAINBOW BITTERSWEET

Late September flowers,
a rainbow bittersweet,
full of glory,
blooms complete.
Dazzling beauties in the afternoon sun,
the last of the butterflies flutter by as if to say farewell.
Rainbow bittersweet.

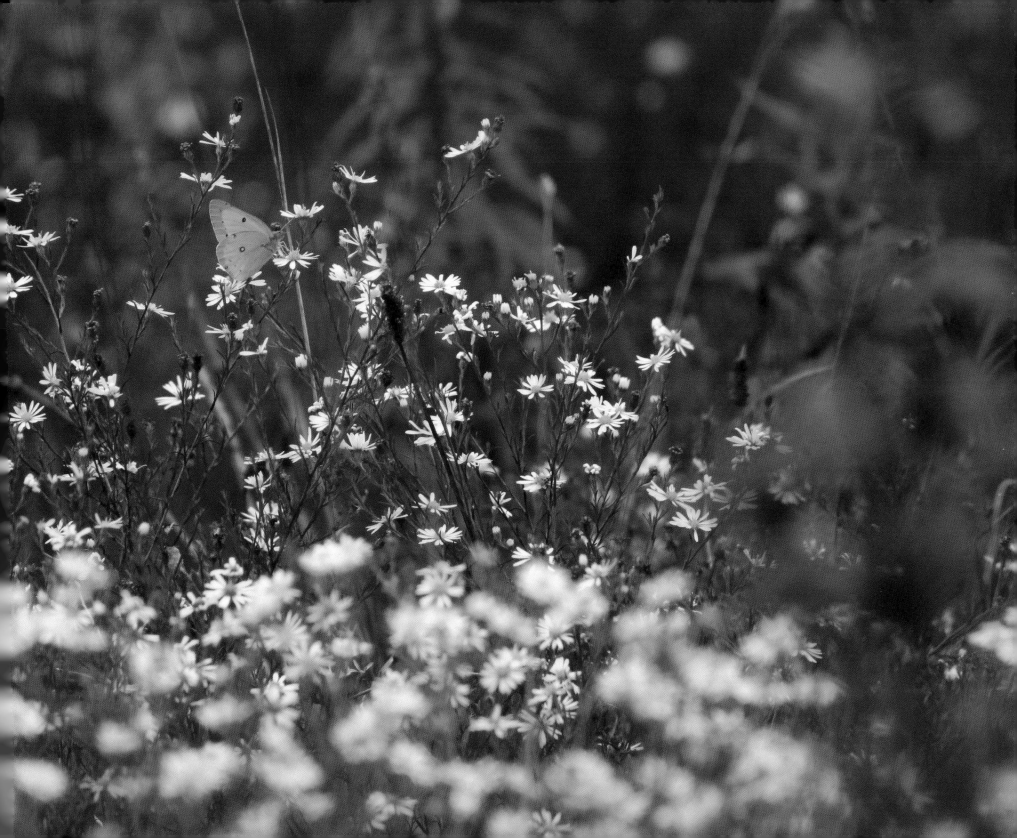

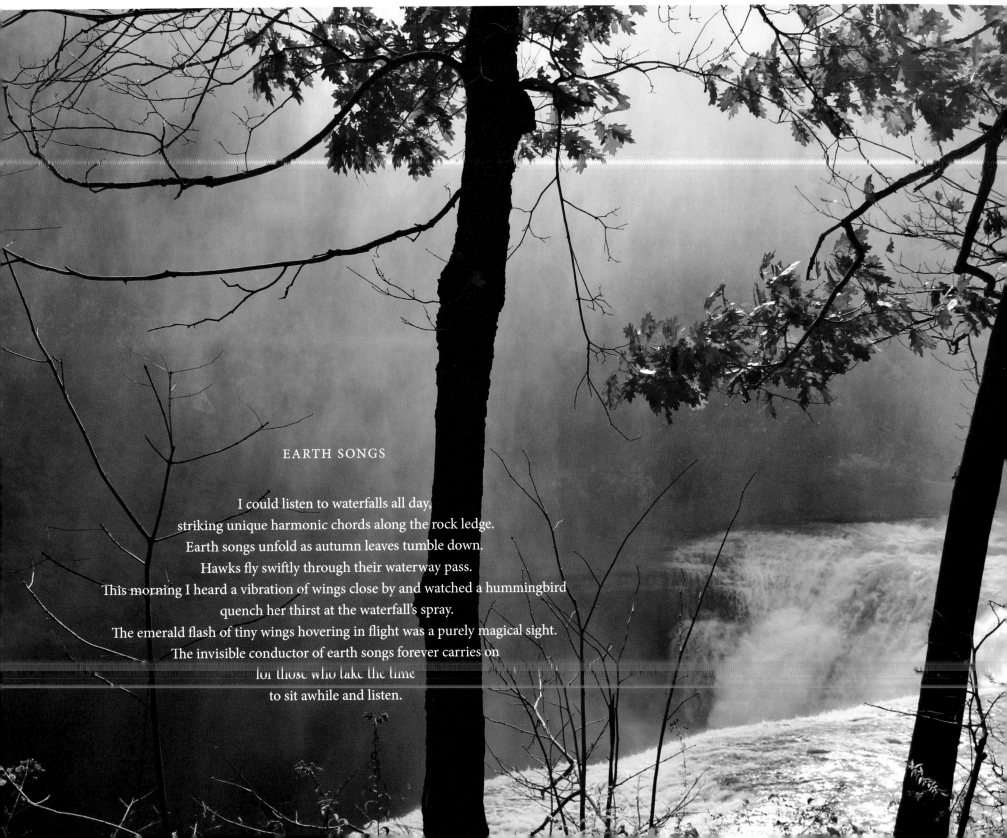

EARTH SONGS

I could listen to waterfalls all day,
striking unique harmonic chords along the rock ledge.
Earth songs unfold as autumn leaves tumble down.
Hawks fly swiftly through their waterway pass.
This morning I heard a vibration of wings close by and watched a hummingbird
quench her thirst at the waterfall's spray.
The emerald flash of tiny wings hovering in flight was a purely magical sight.
The invisible conductor of earth songs forever carries on
for those who take the time
to sit awhile and listen.

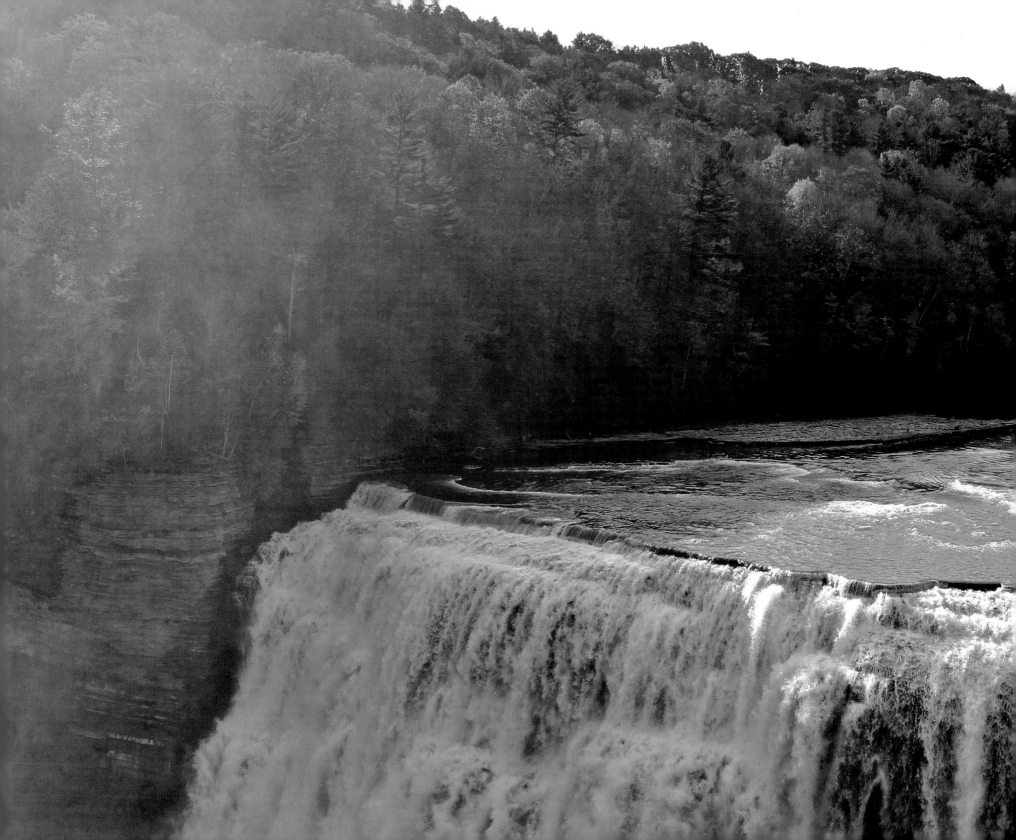

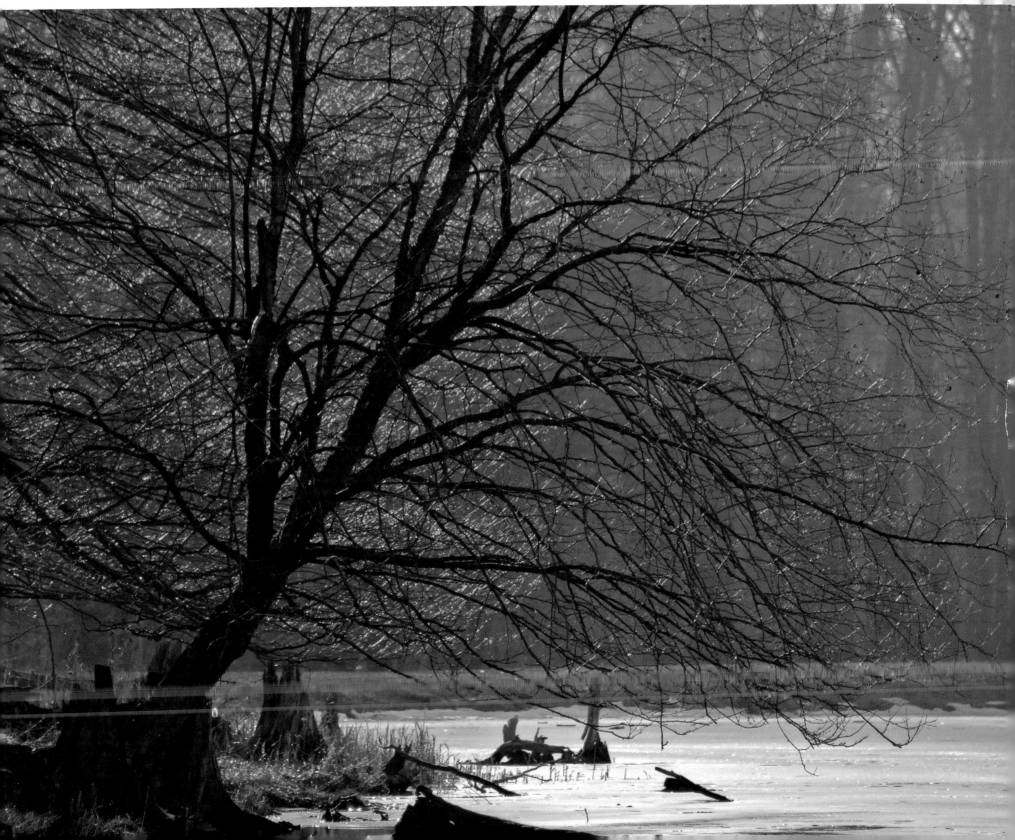

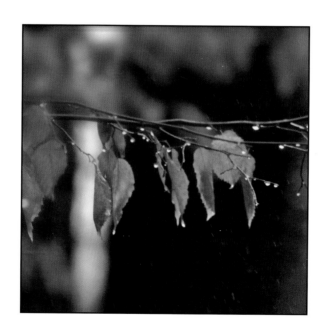

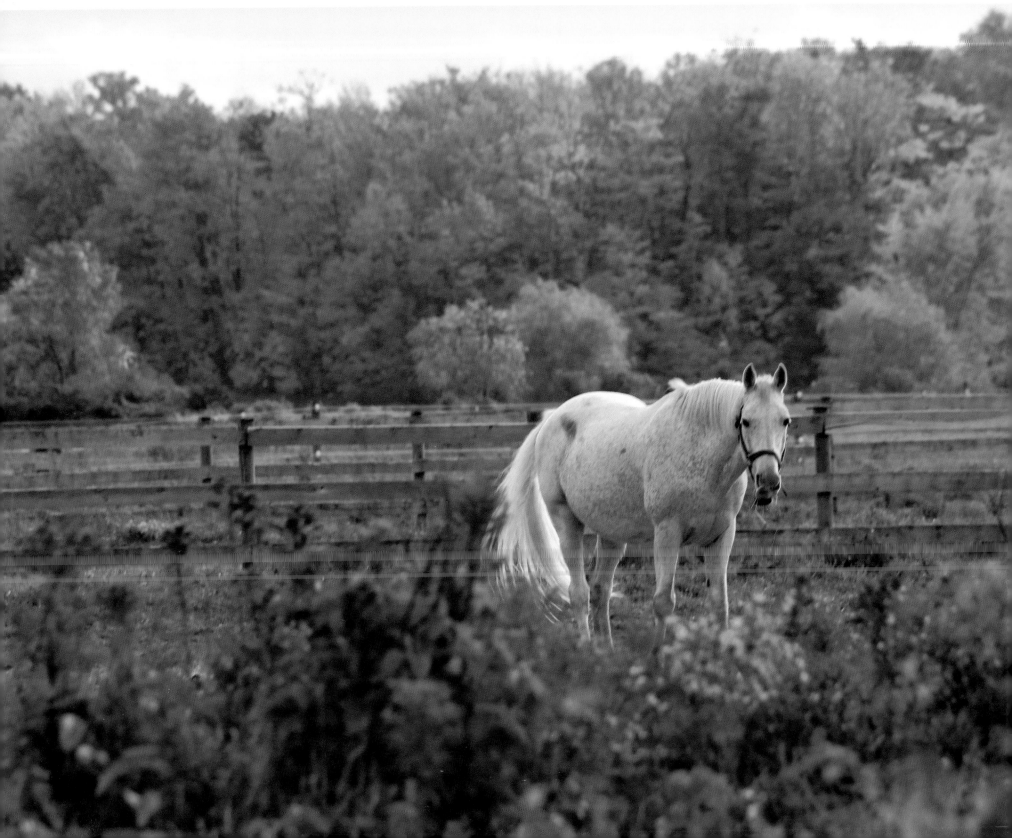

PRINCE OF THE HILLS

I compose a painting every time I wander past these hills,
of autumn splendor under clear blue skies.
And you, white horse,
prince of the hills,
I'll use my finest brushes and place you center stage
but know I'll never come even close to true
while painting sunshine on your withers under October skies so blue.

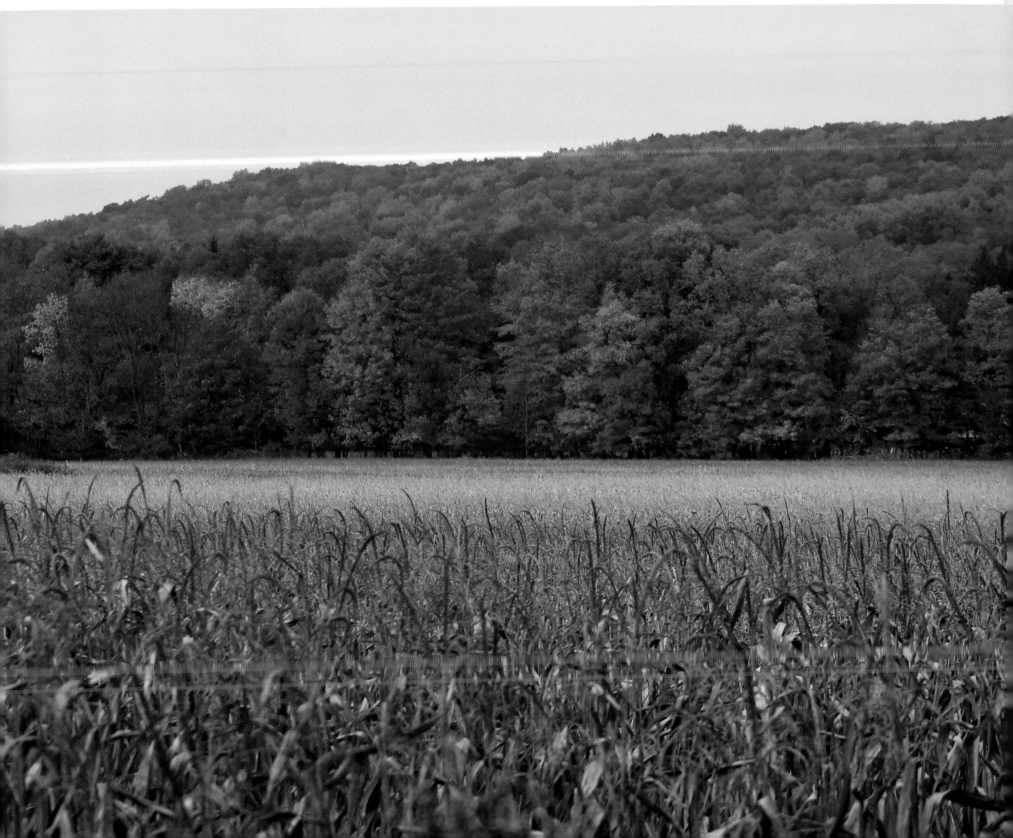

GOLDEN TIME

The cornfields at rest,
the hay has been gathered,
the nights come sooner now.
The oranges heat up like molten glass,
the reds like scarlet wine.
The light is sharper, nature's spectrum hits its stride.
It is golden time.

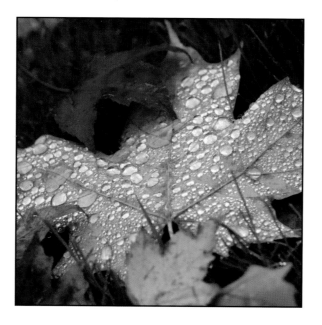

NOVEMBER MOOD

The leaves have fallen leaving new views
of winter berries and frosted fields.
The birches bare their silken faces,
and the world whispers in silver.

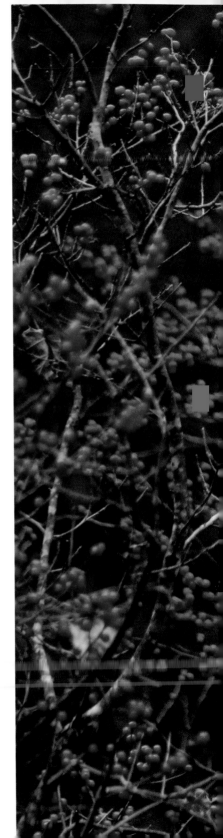

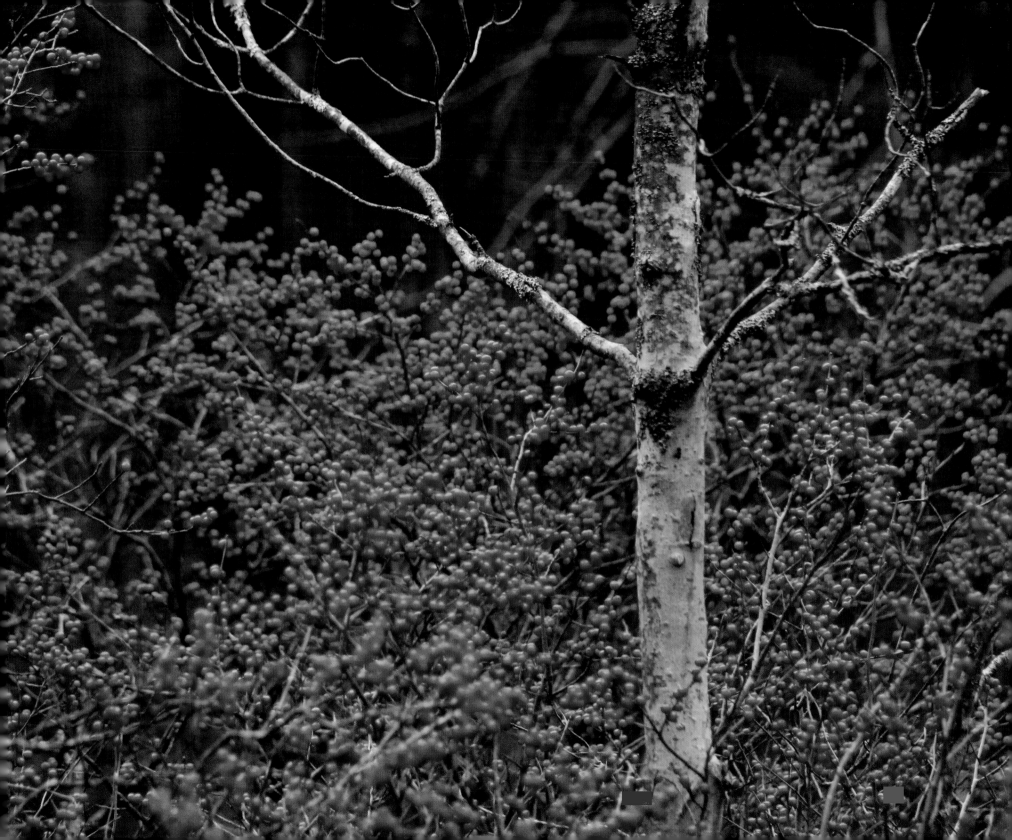

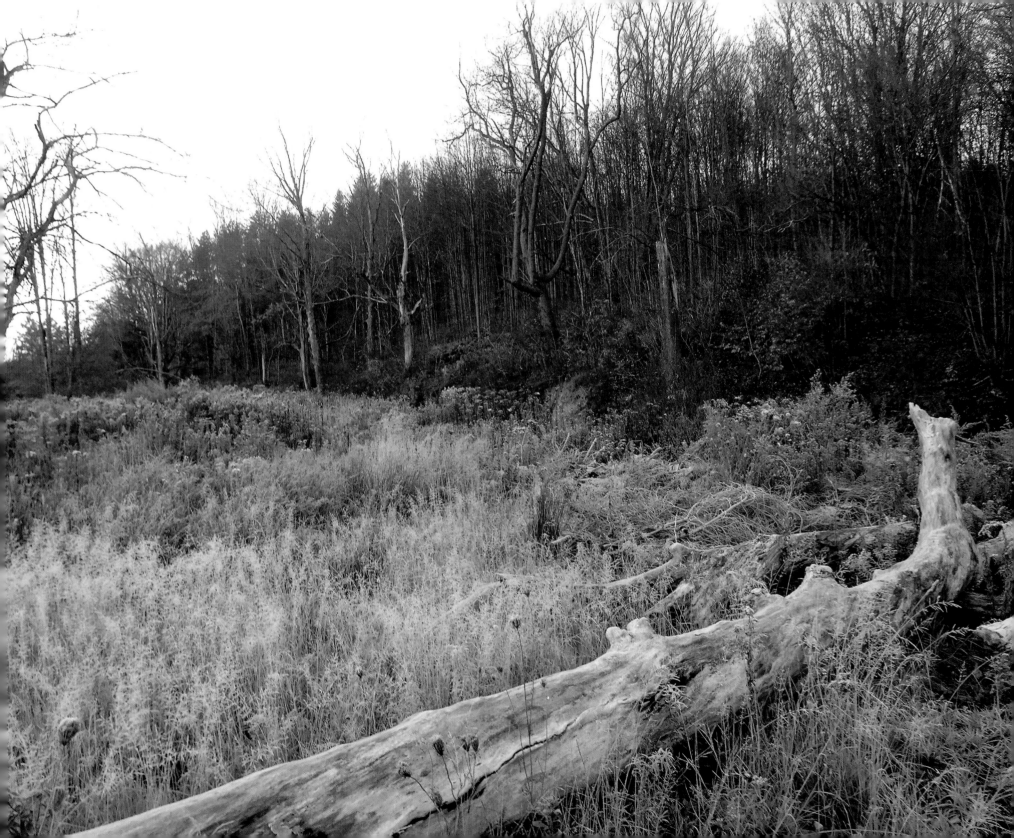

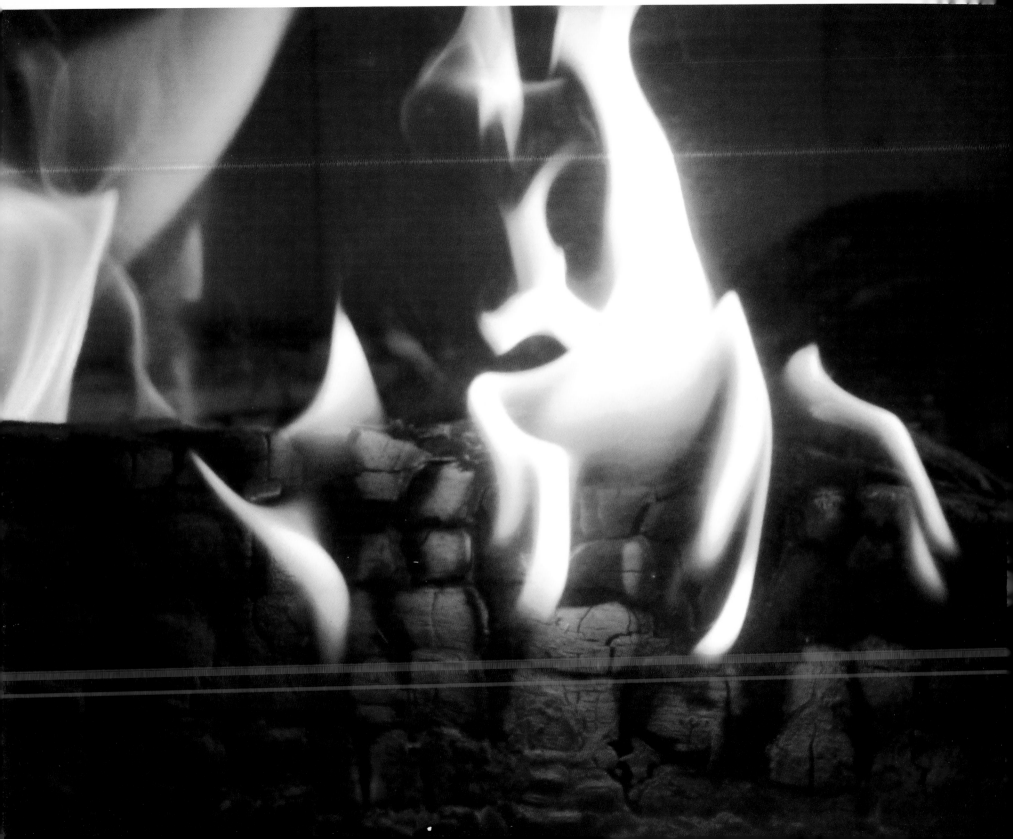

FIRST FIRE

Axes splitting,
wood cracking,
late Autumn echoes through the woods.
Cawing crows swoop down, pecking at harvest remains.
Goldfinches perched on thistle and bluejays everywhere.
Tonight we'll make the first fire and drink spiced cider.
Winter's almost here.

ABOUT THE AUTHOR

Wende Essrow is a self-taught artist who
has been writing poetry and stories for as
long as she can remember. She began taking
photographs as a way to gather references
for her art, and for many years carried
a pocket camera whenever she was out
hiking or cross-country skiing. She now
uses photography as another, important
form of artistic expression. She has written
and illustrated several children's books.
At First Light, her first book for adults, is
a celebration of the beauty of the natural world through the seasons.
Wende lived in the woods with her husband and two dogs in West
Falls, a small town in Western New York, for nearly a decade. *At First
Light* has turned out to be her way of taking that idyllic region with her
to her new home in the woods of North Carolina.